# Boudoir
## COLORING BOOK

A Cultural Cornucopia of Romance and Beauty

Laurie Triefeldt

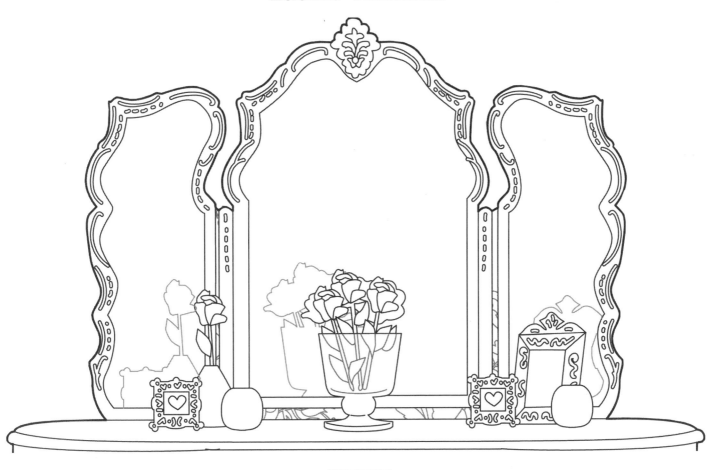

Quill
Driver
Books

Fresno, California

*Boudoir Coloring Book*
Copyright ©2016 by Laurie Triefeldt. All rights reserved.

Published by Quill Driver Books,
an imprint of Linden Publishing

2006 South Mary, Fresno, California 93721
559-233-6633 / 800-345-4447
QuillDriverBooks.com

Quill Driver Books and Colophon
are trademarks of Linden Publishing, Inc.

ISBN 978-1-61035-286-4

Printed in the United States
First Printing
Library of Congress Cataloging-in-Publication Data on file

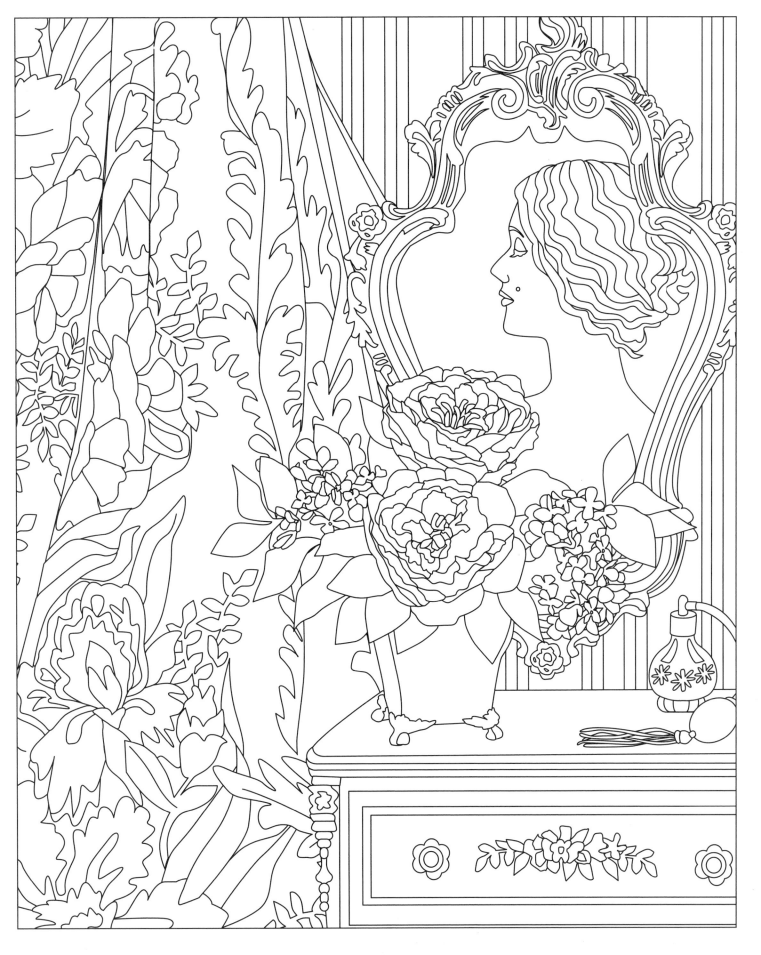

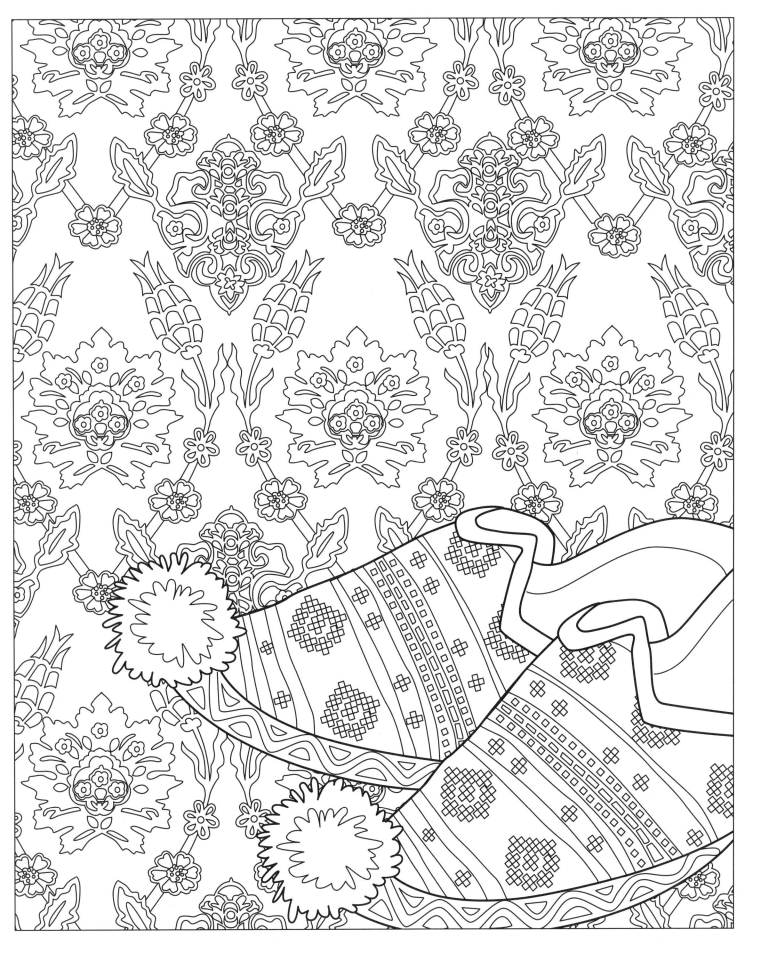

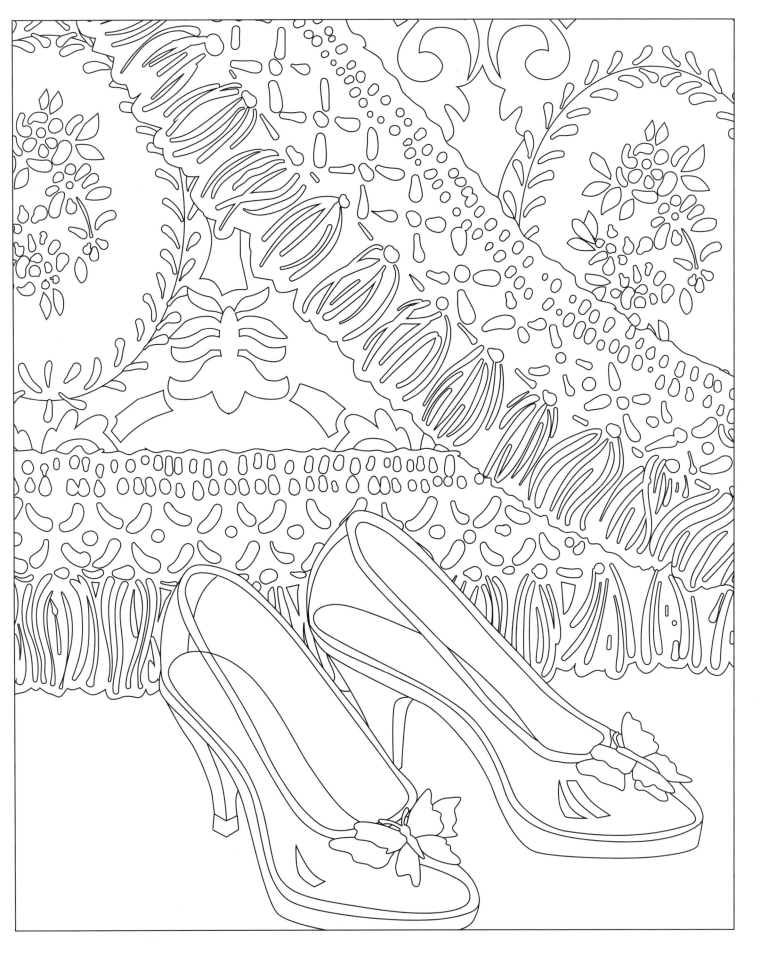

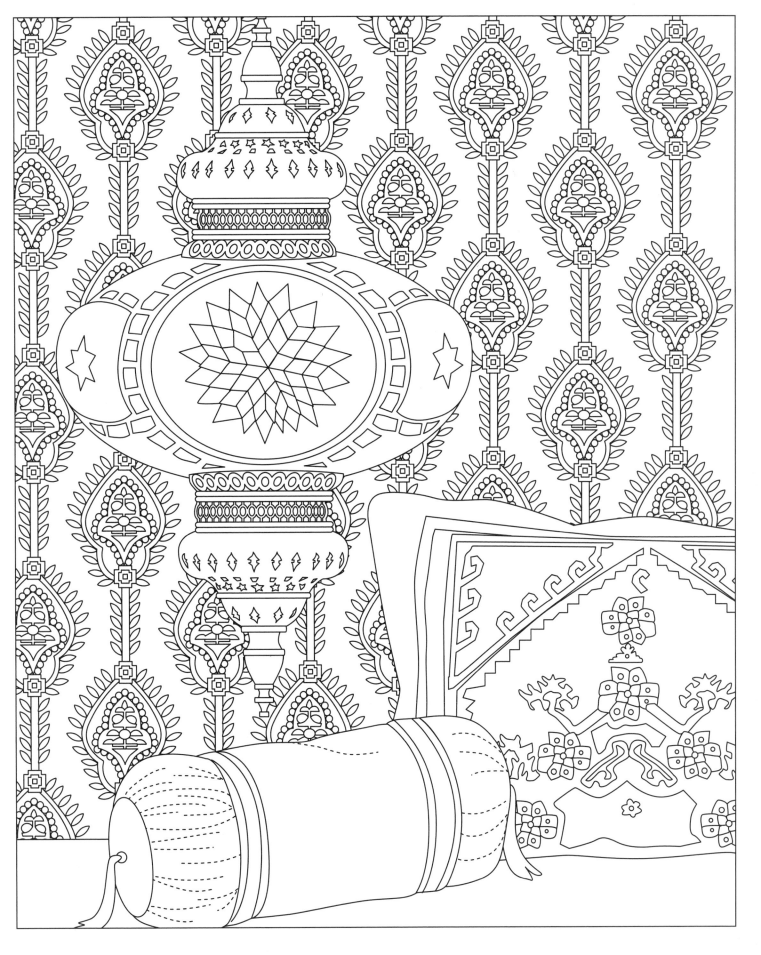

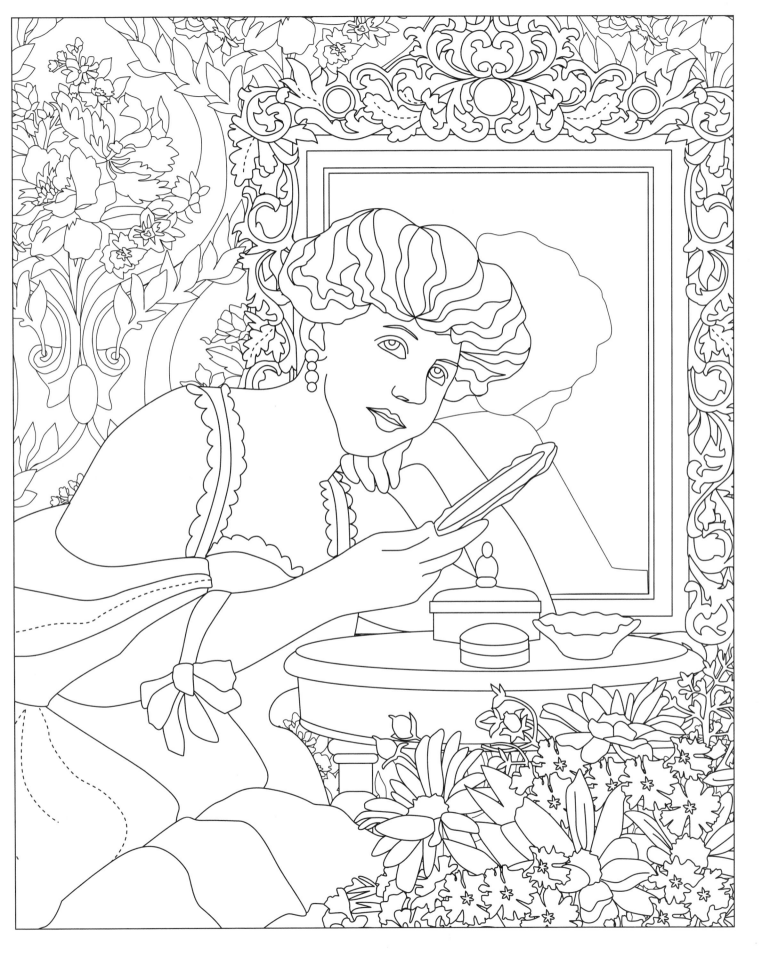

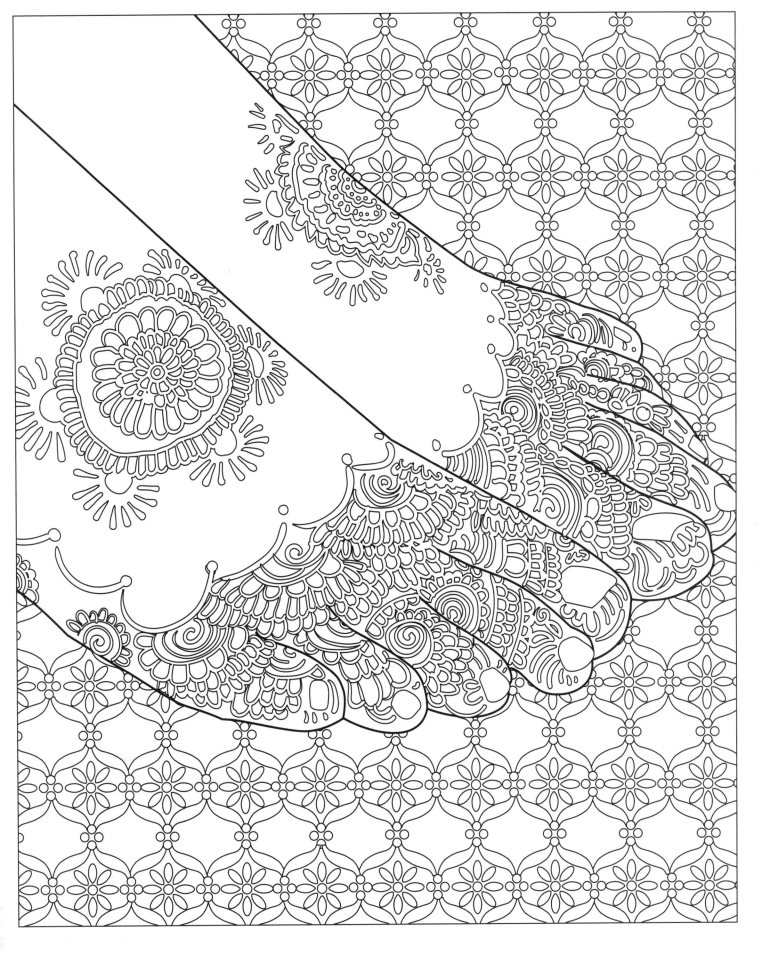

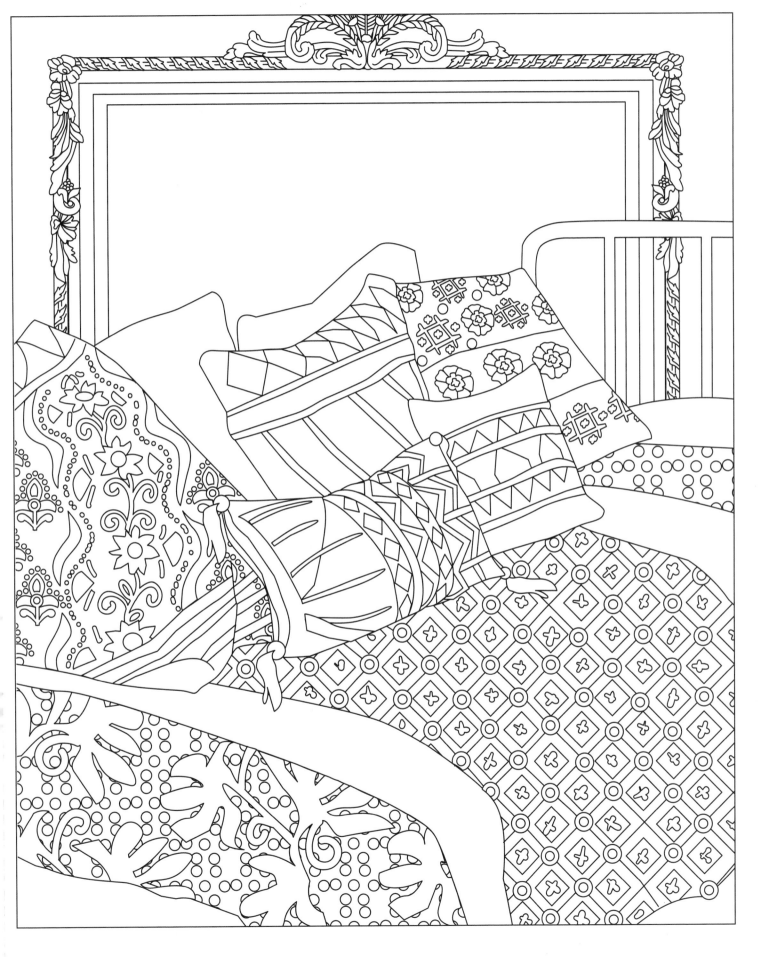

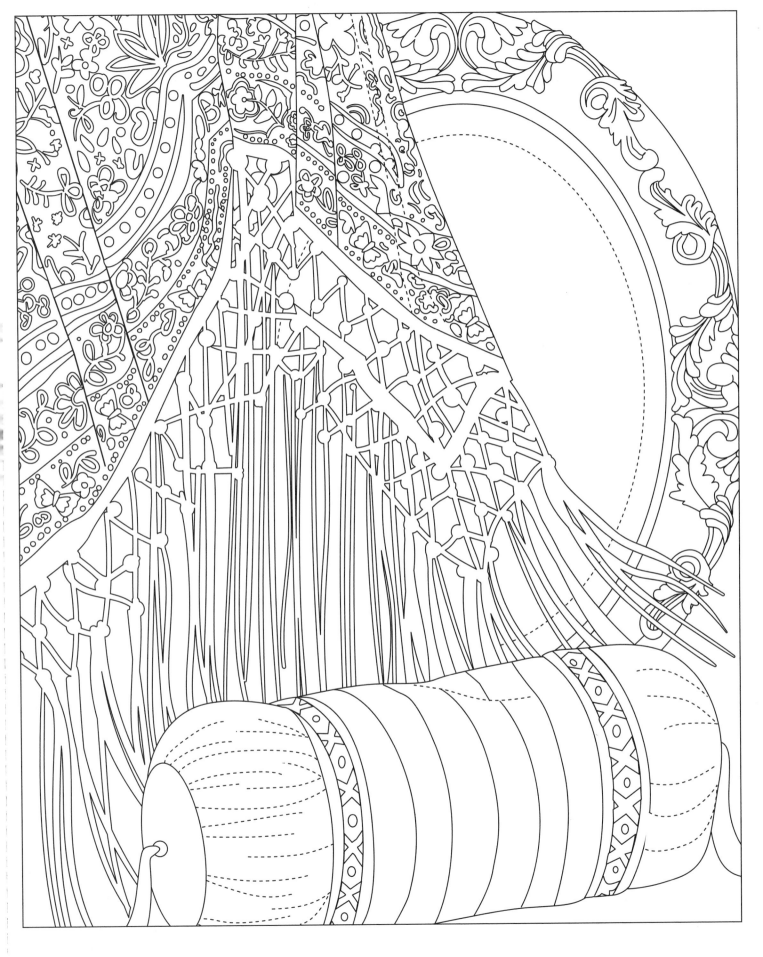

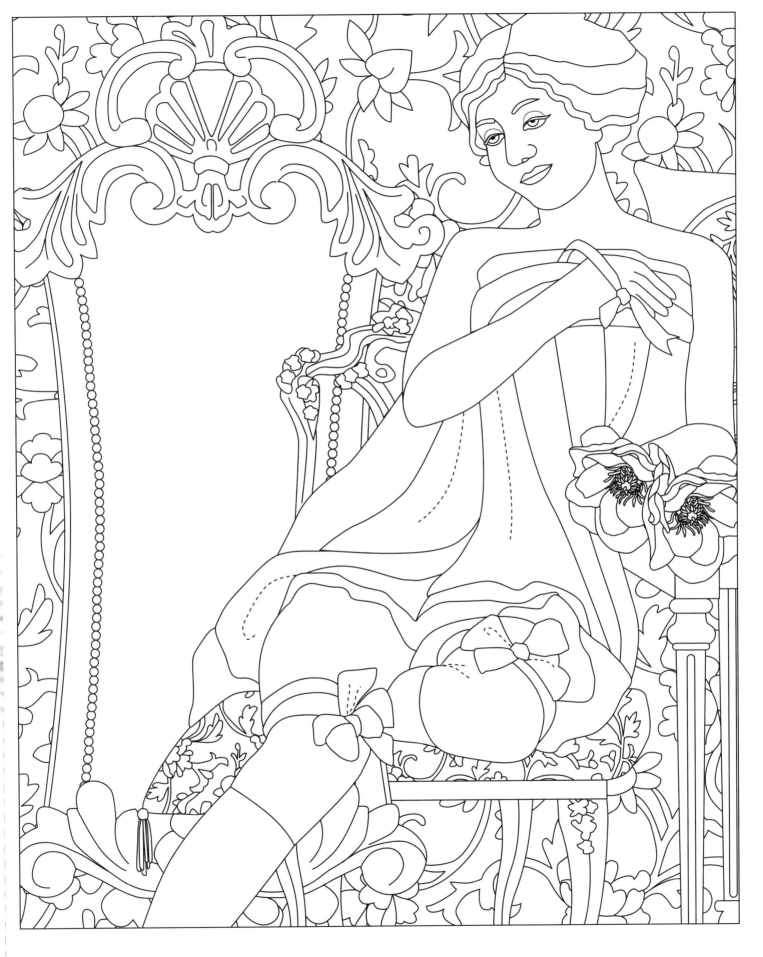

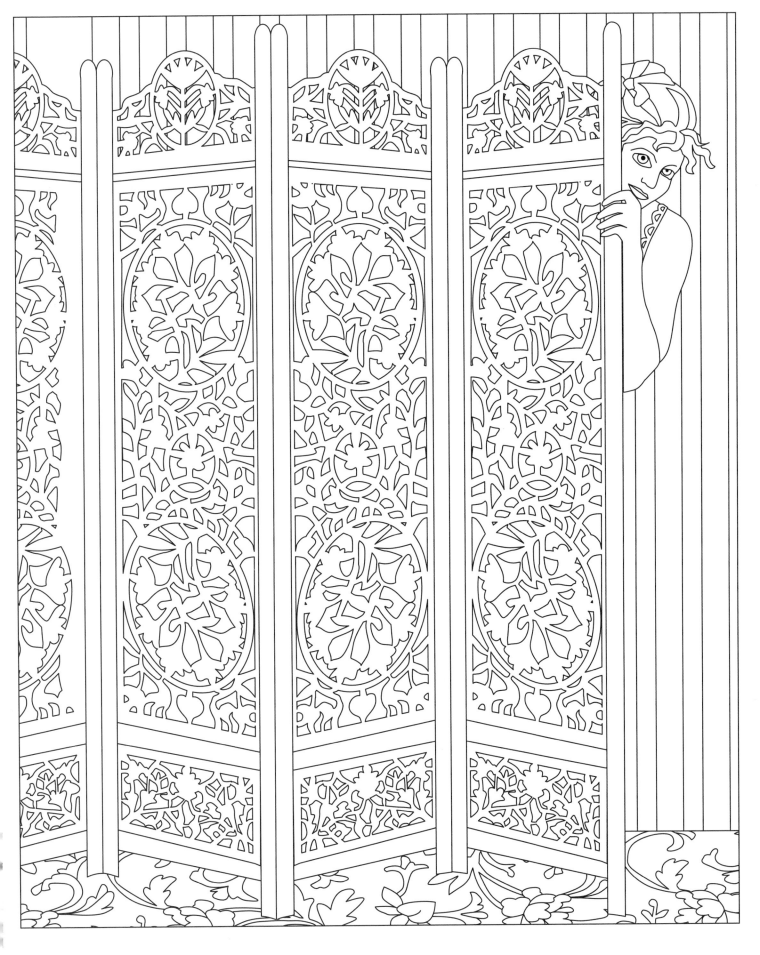

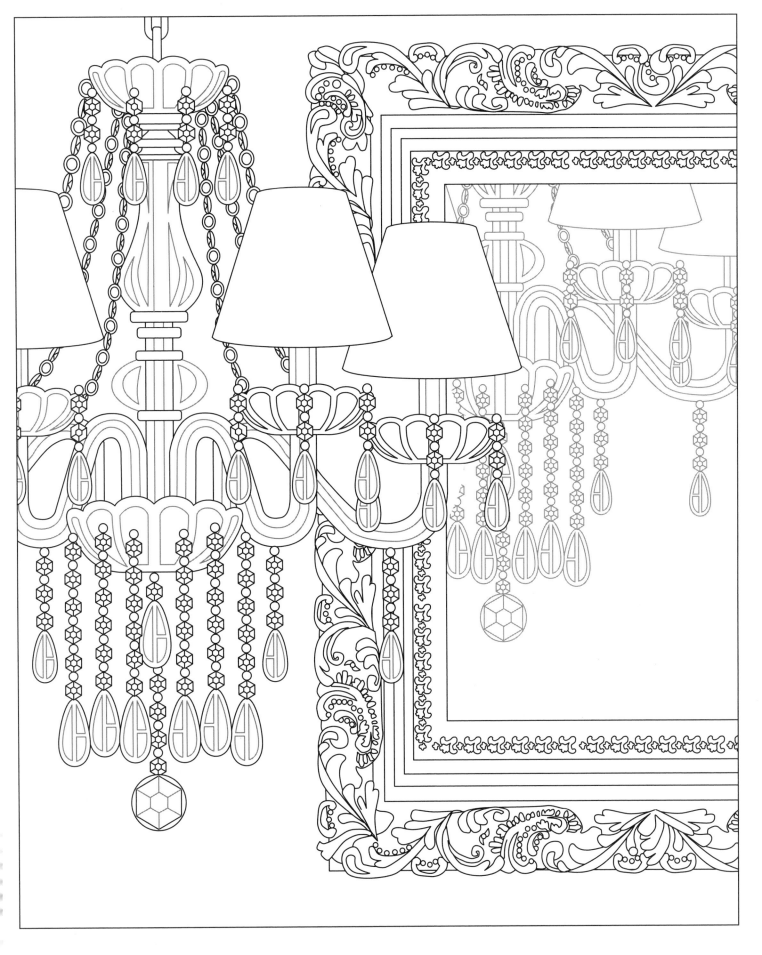

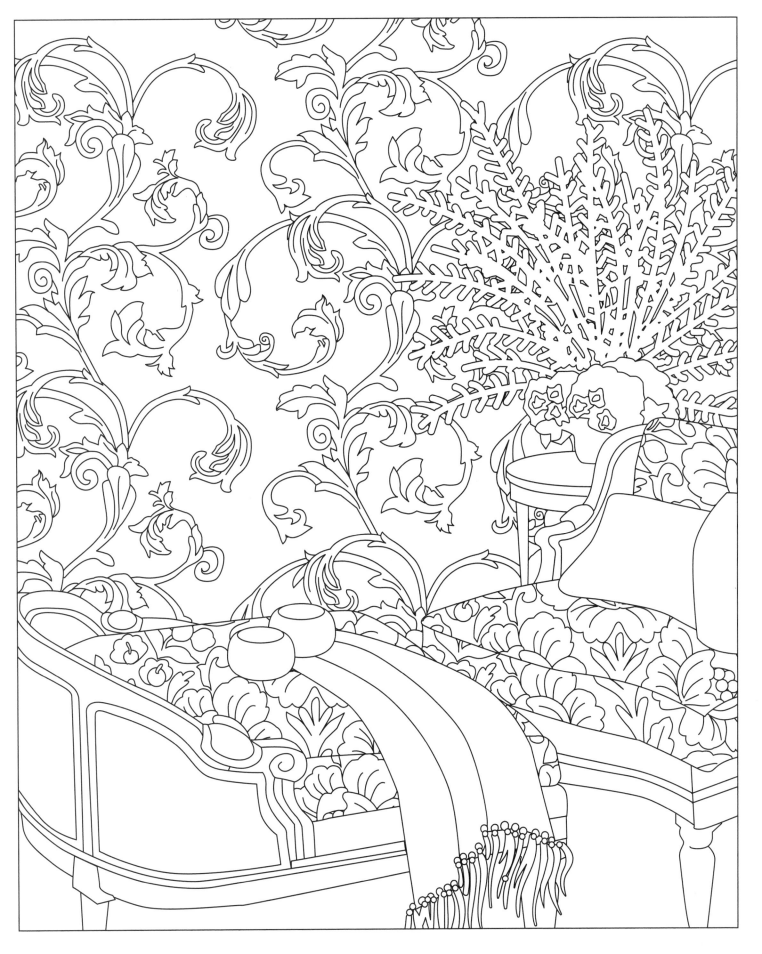

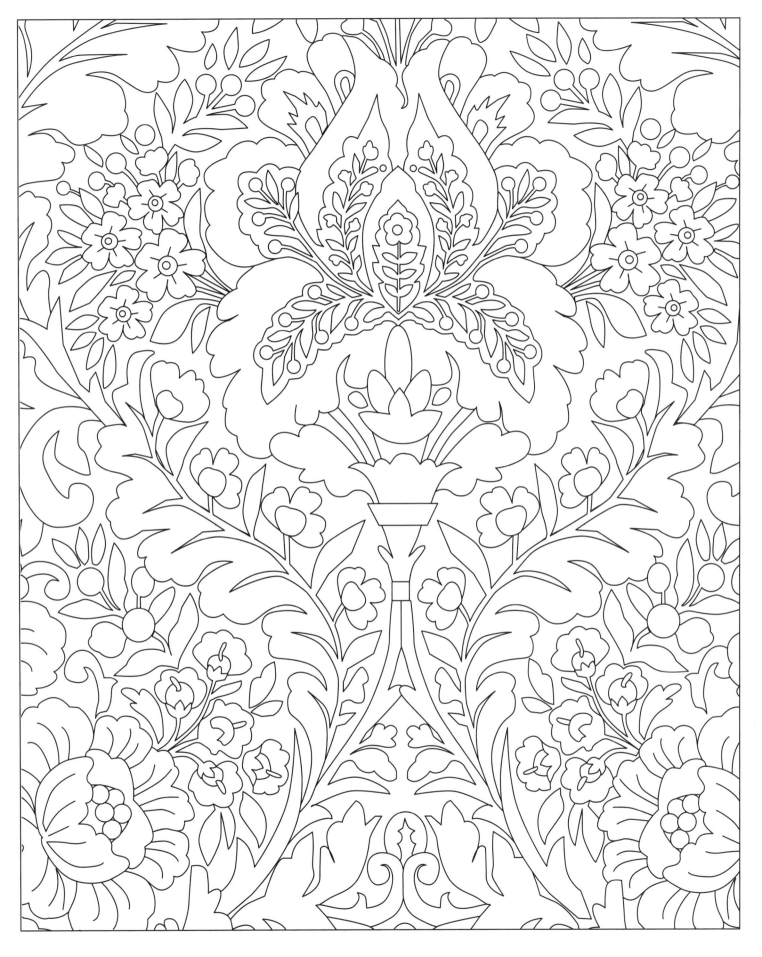

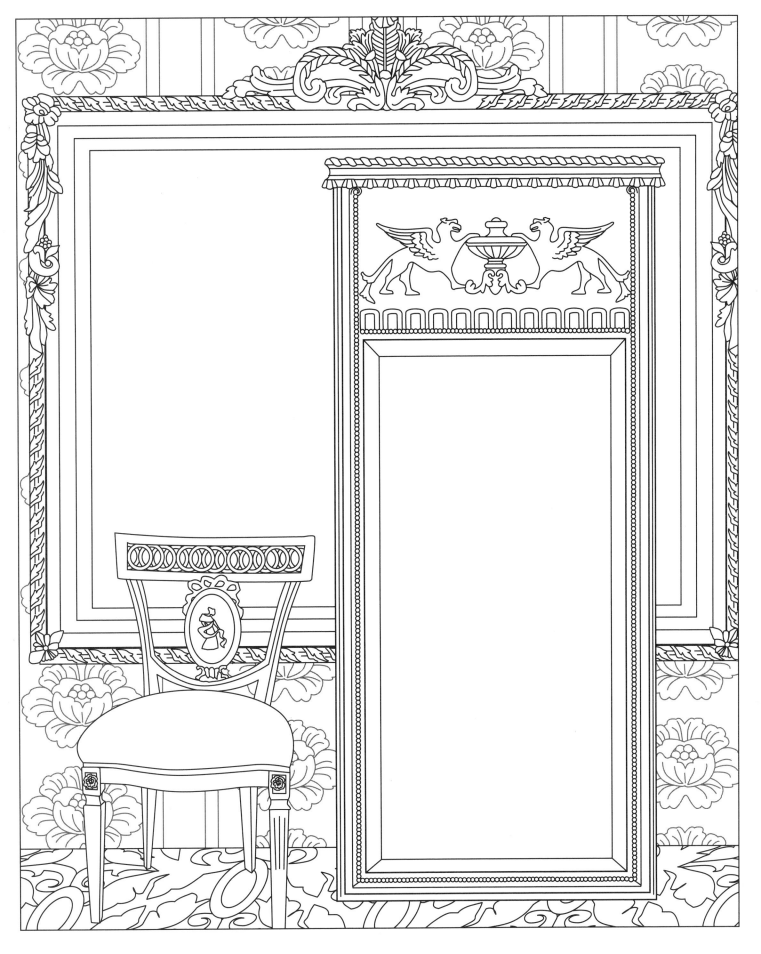

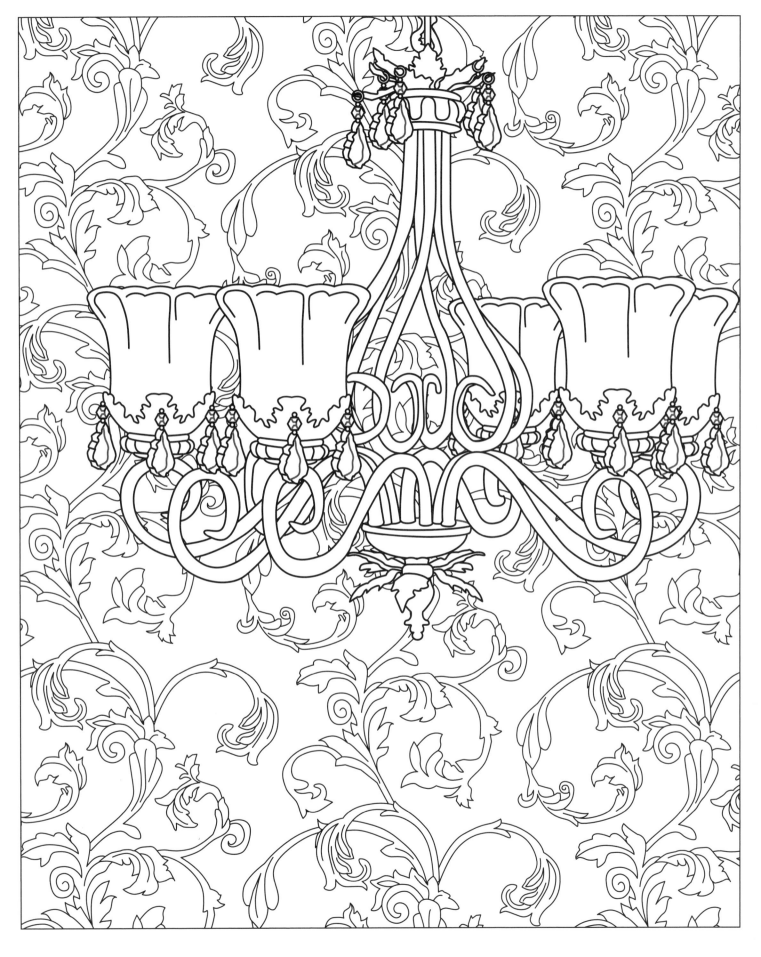

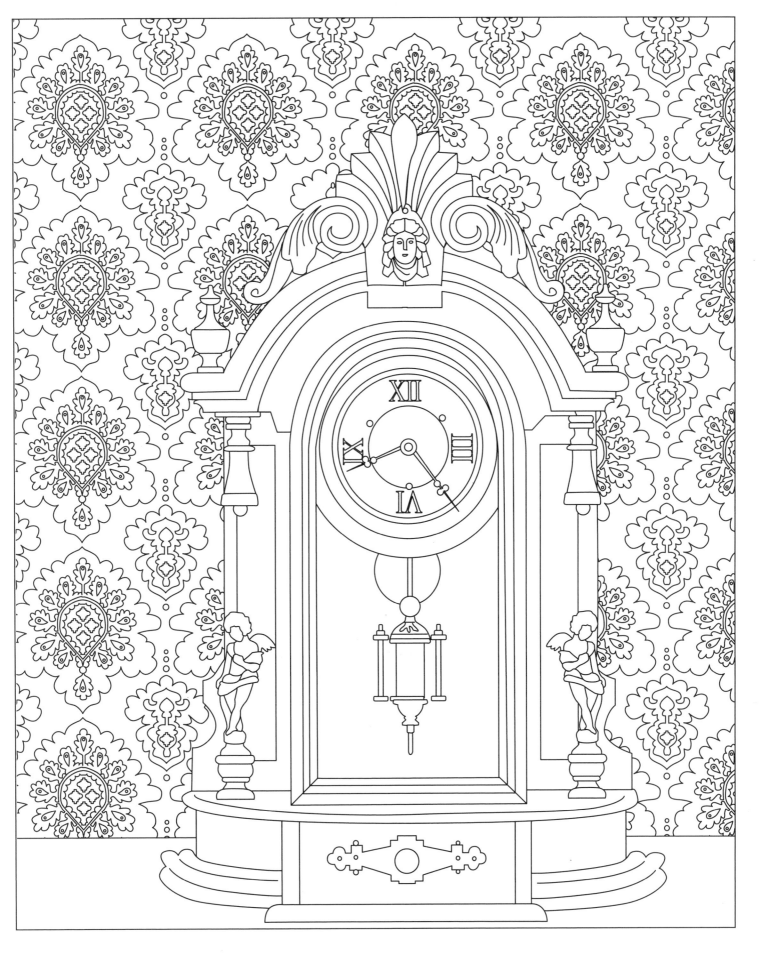

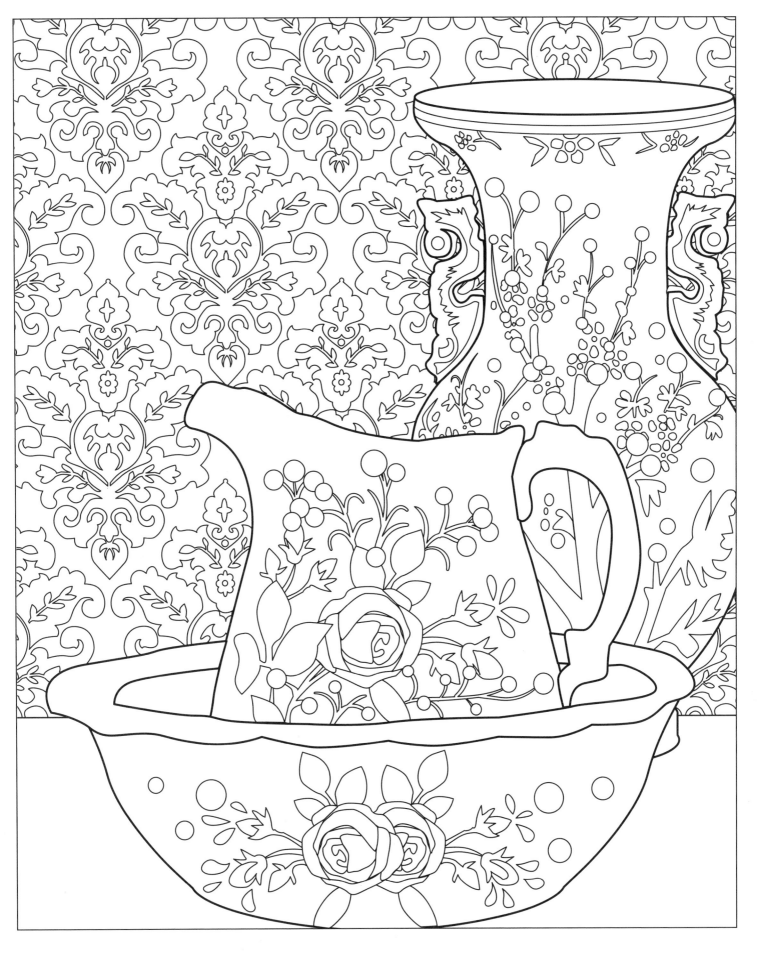

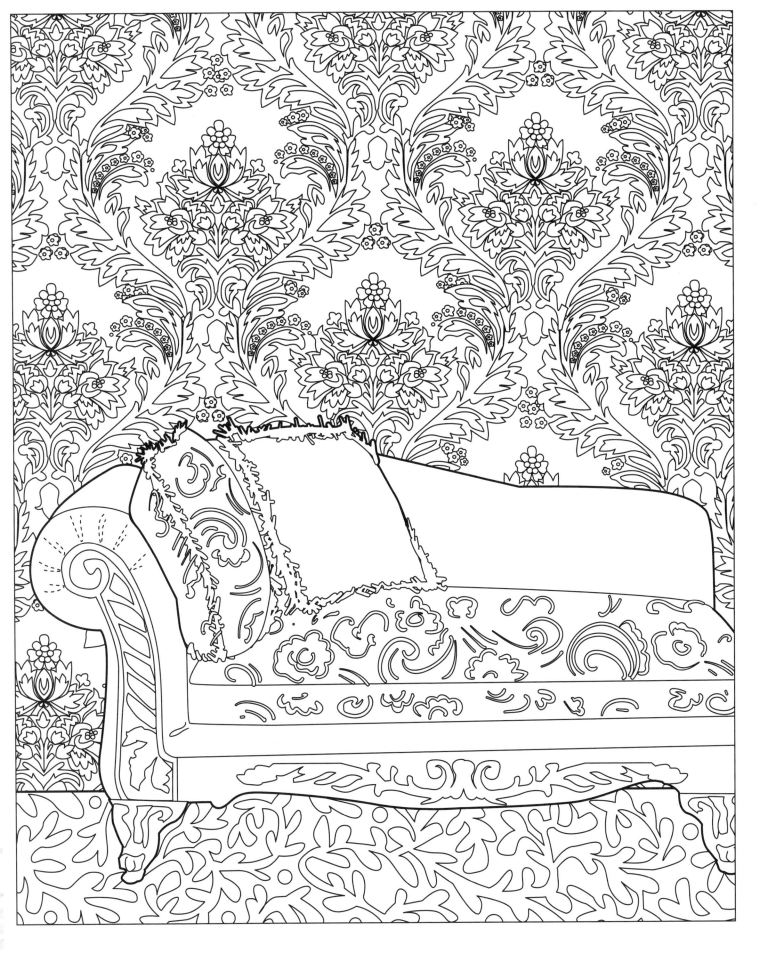

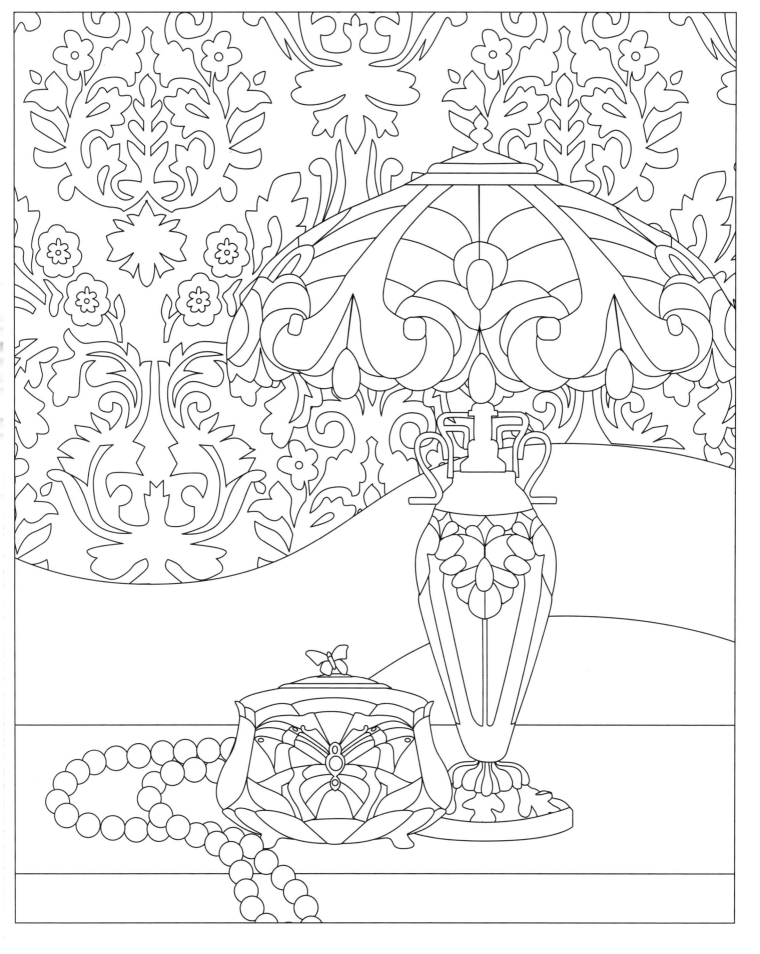

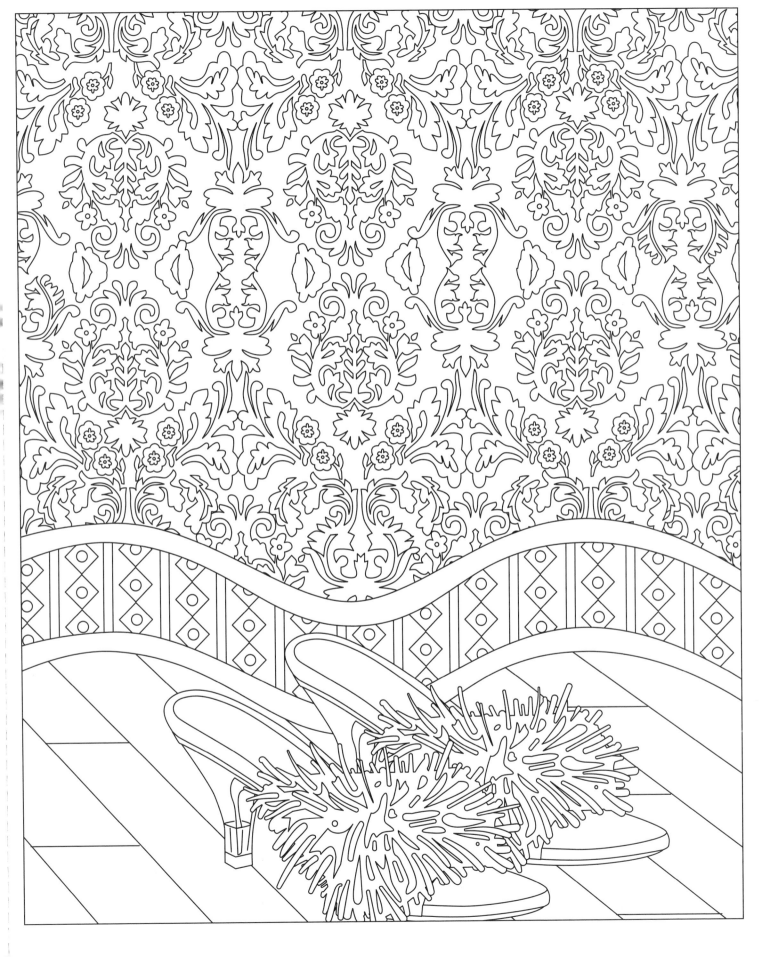

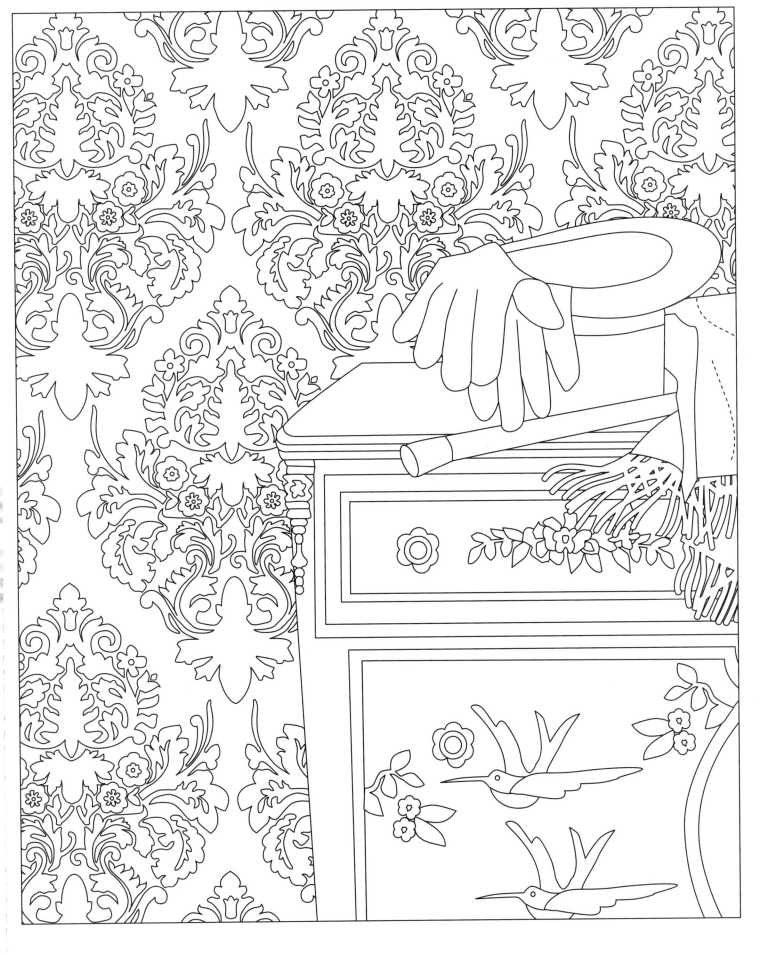

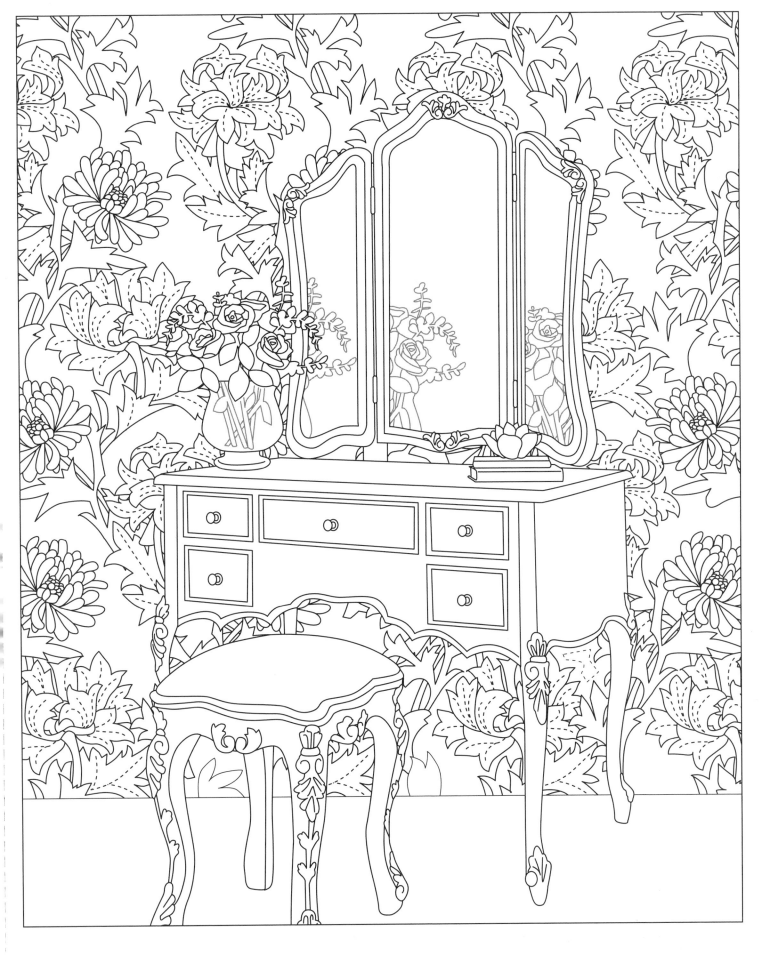

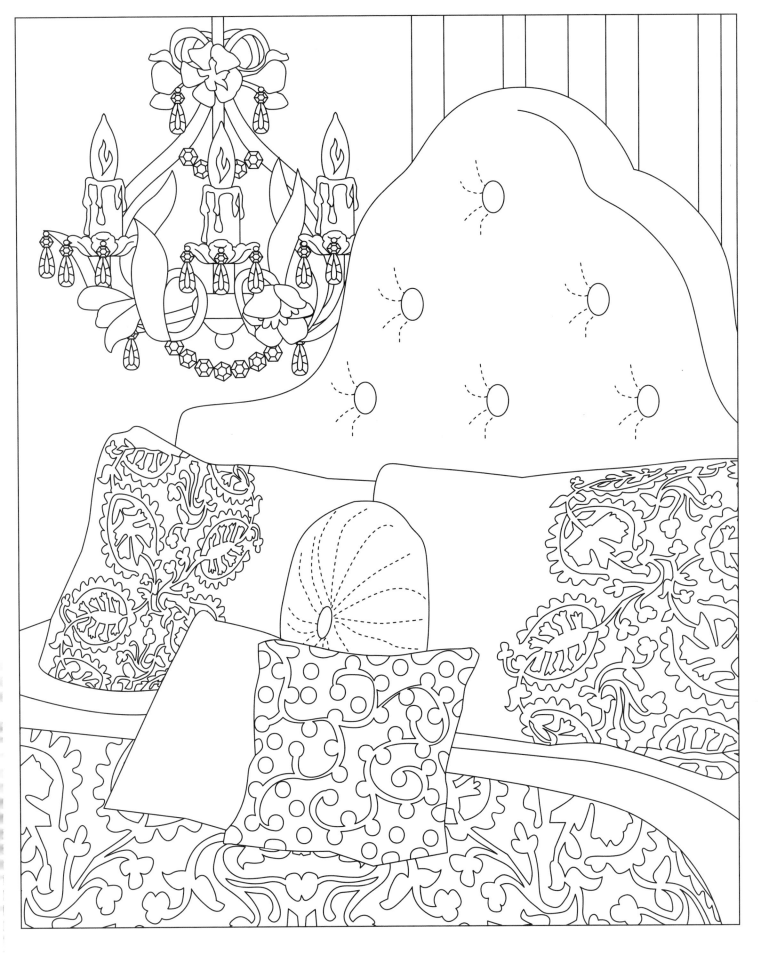

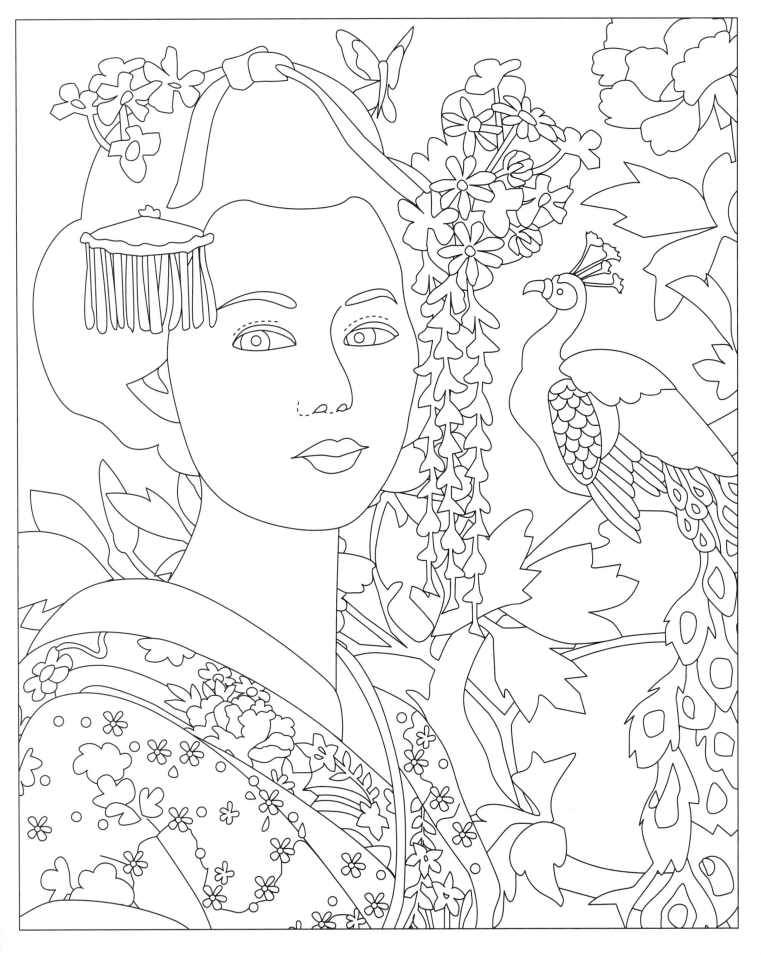

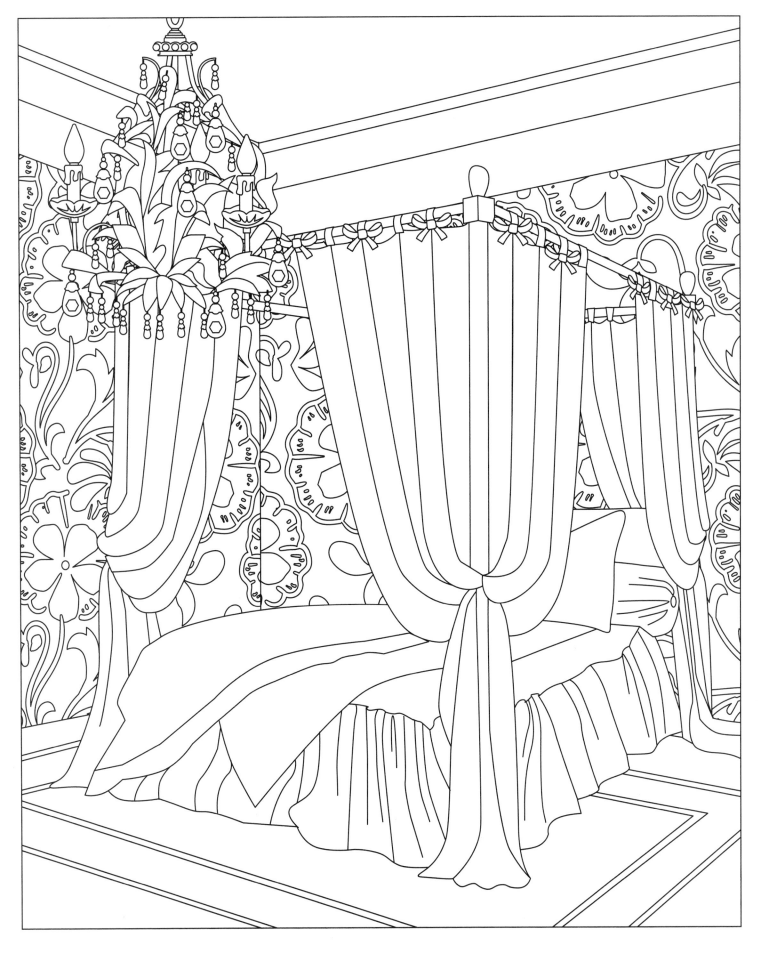

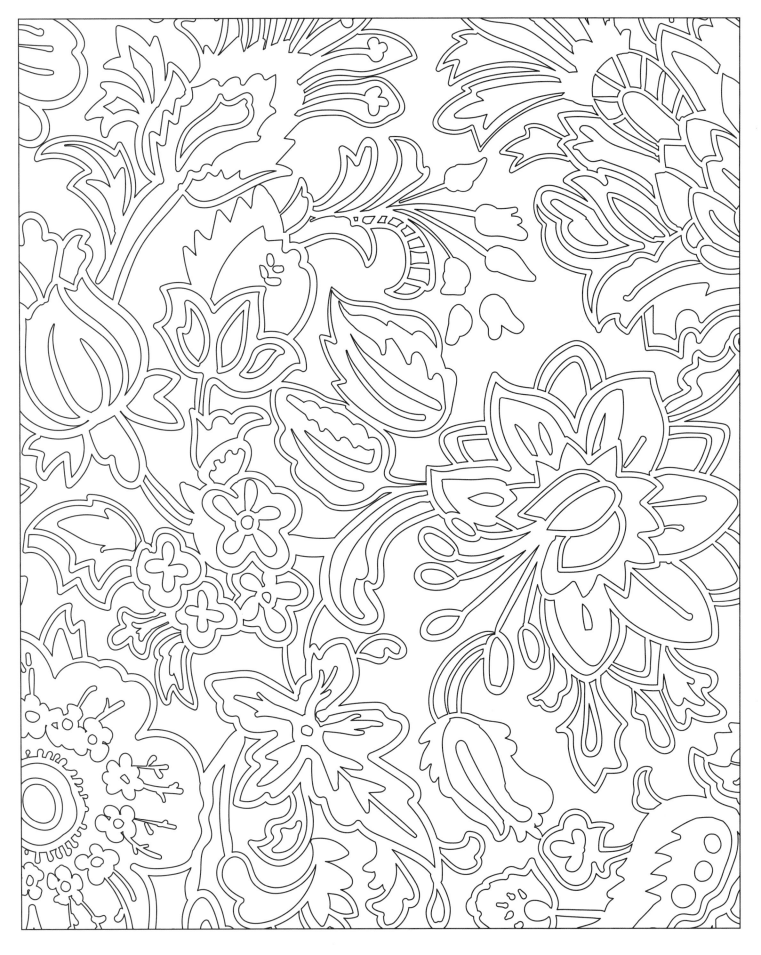

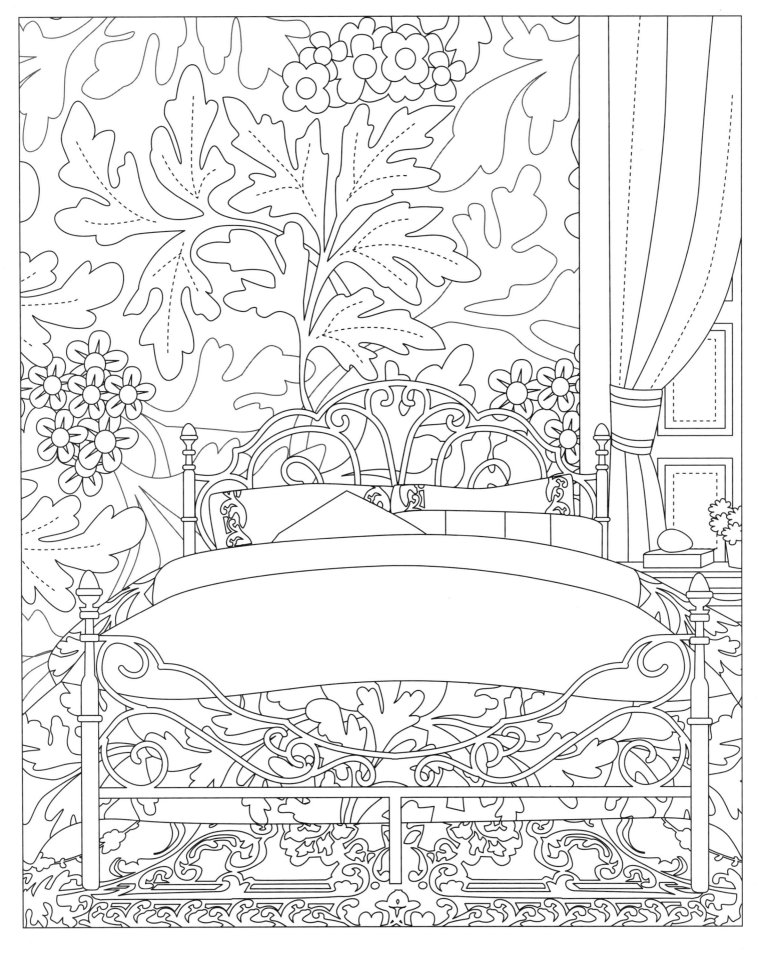

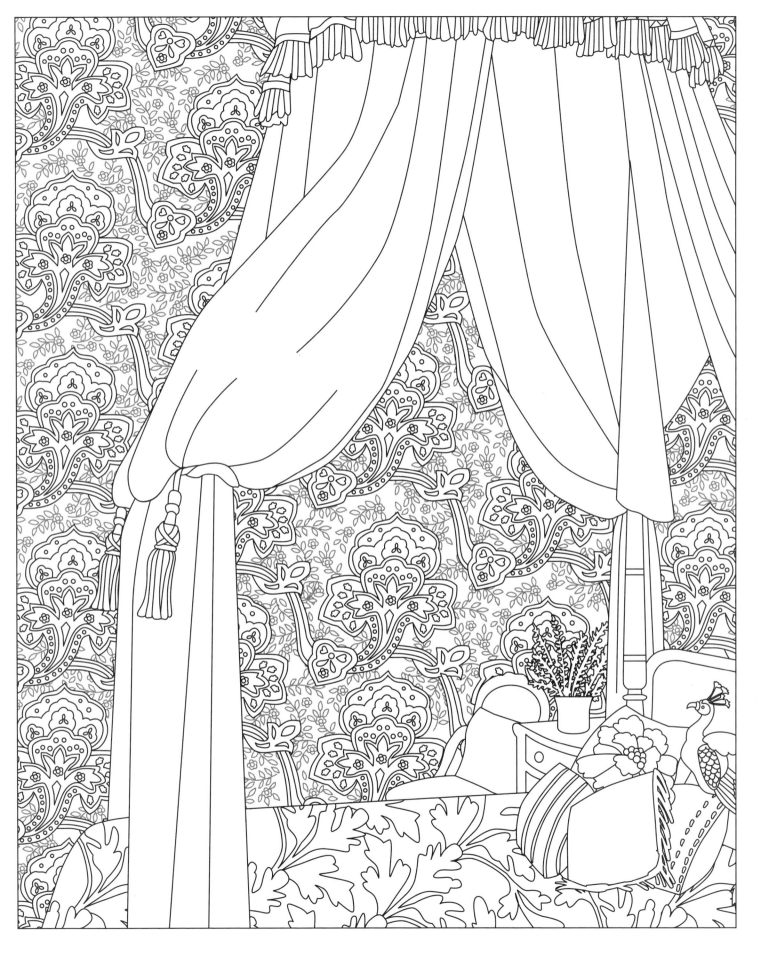

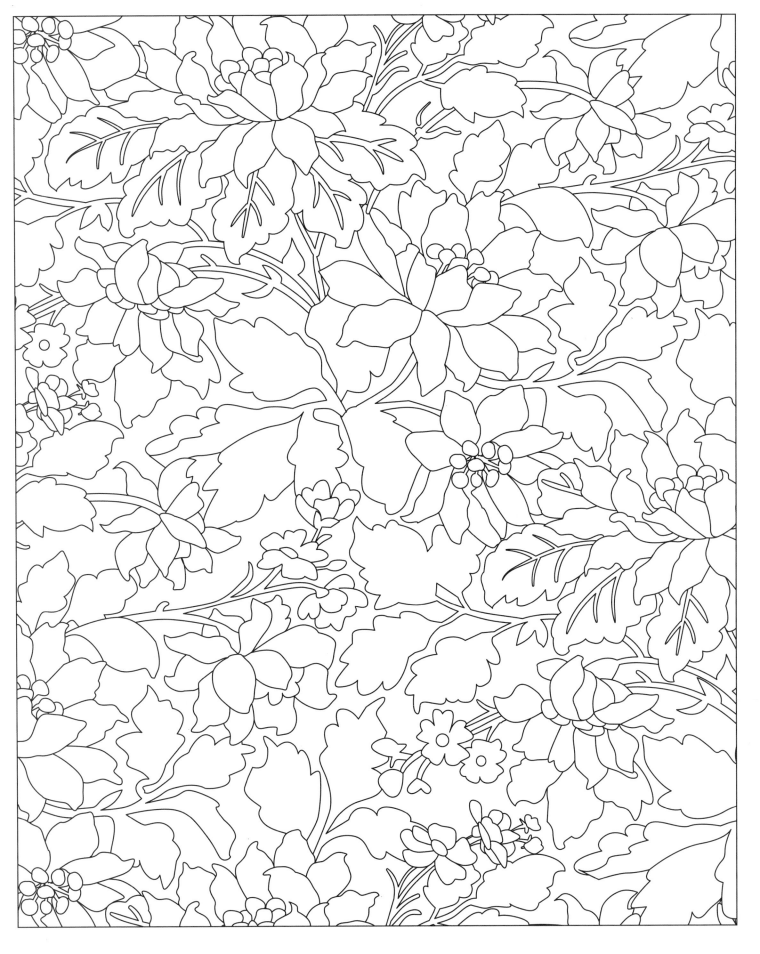

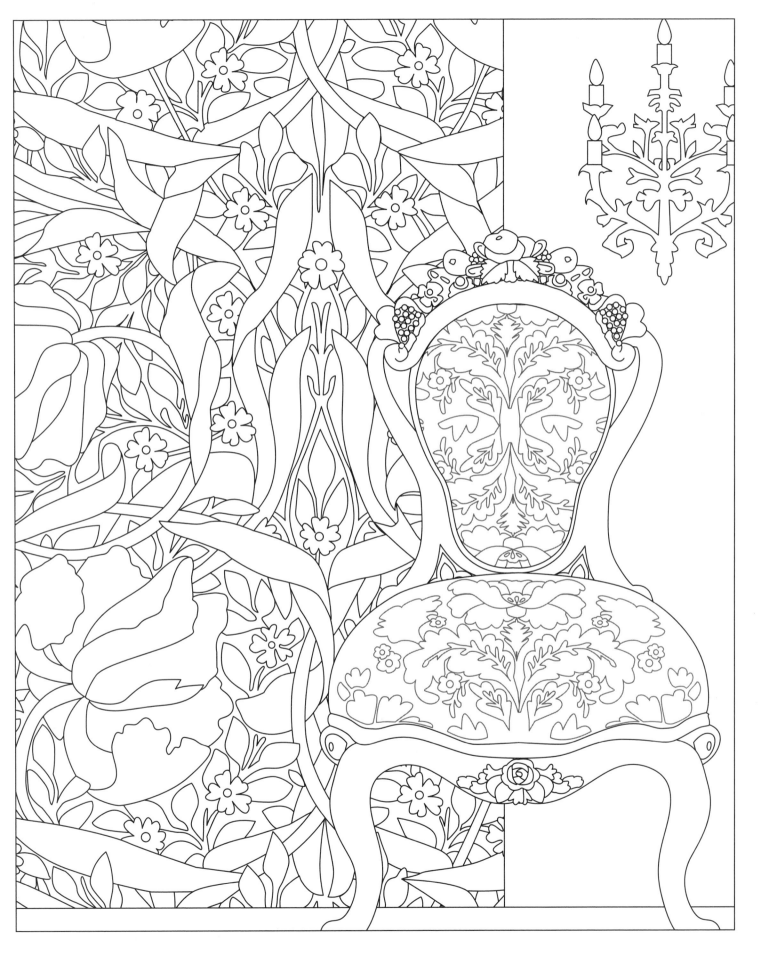

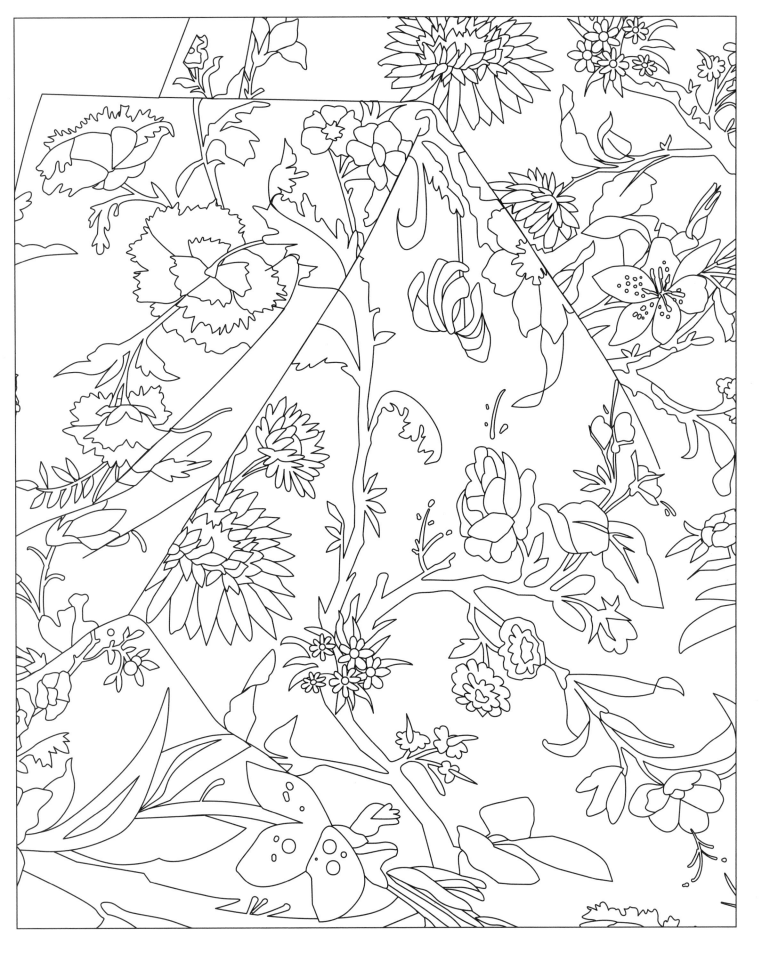

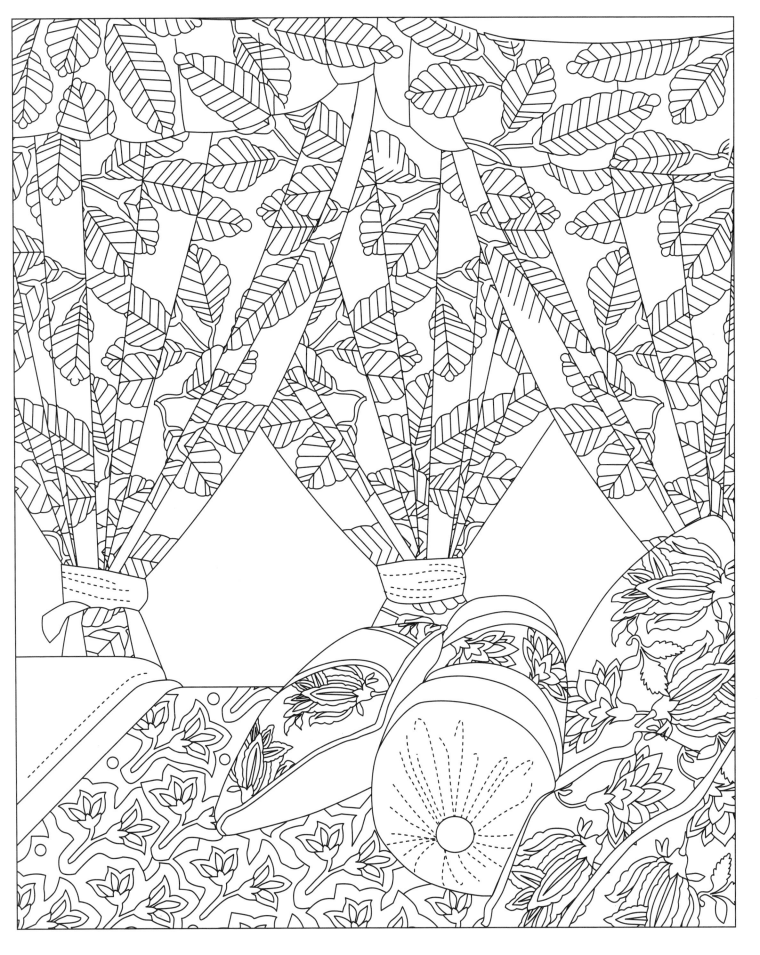

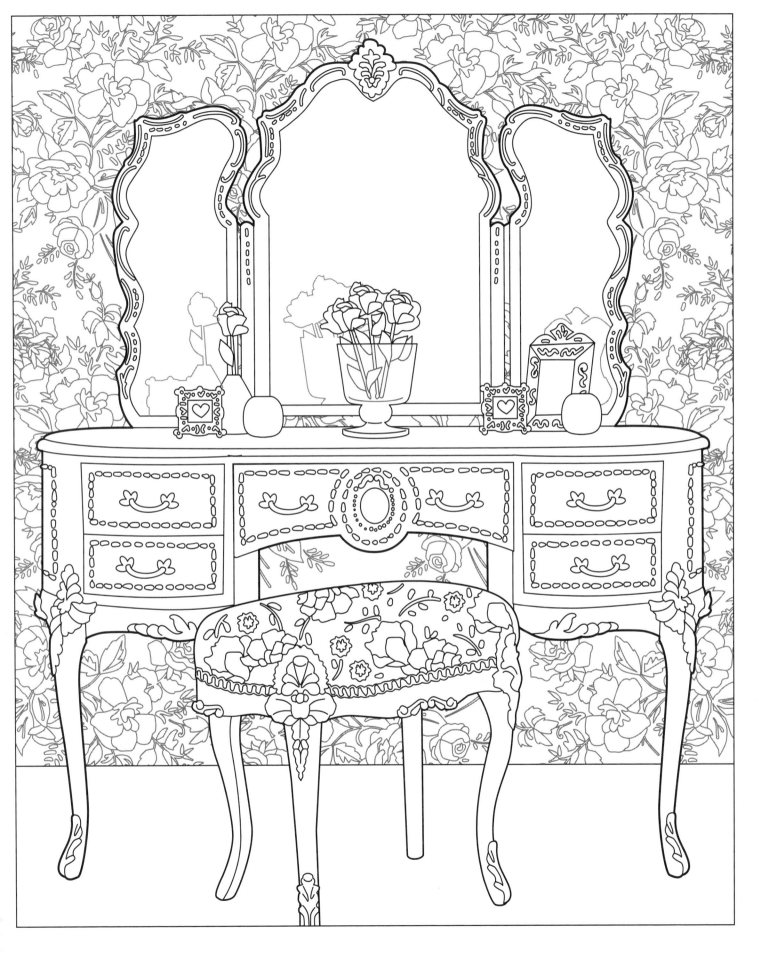

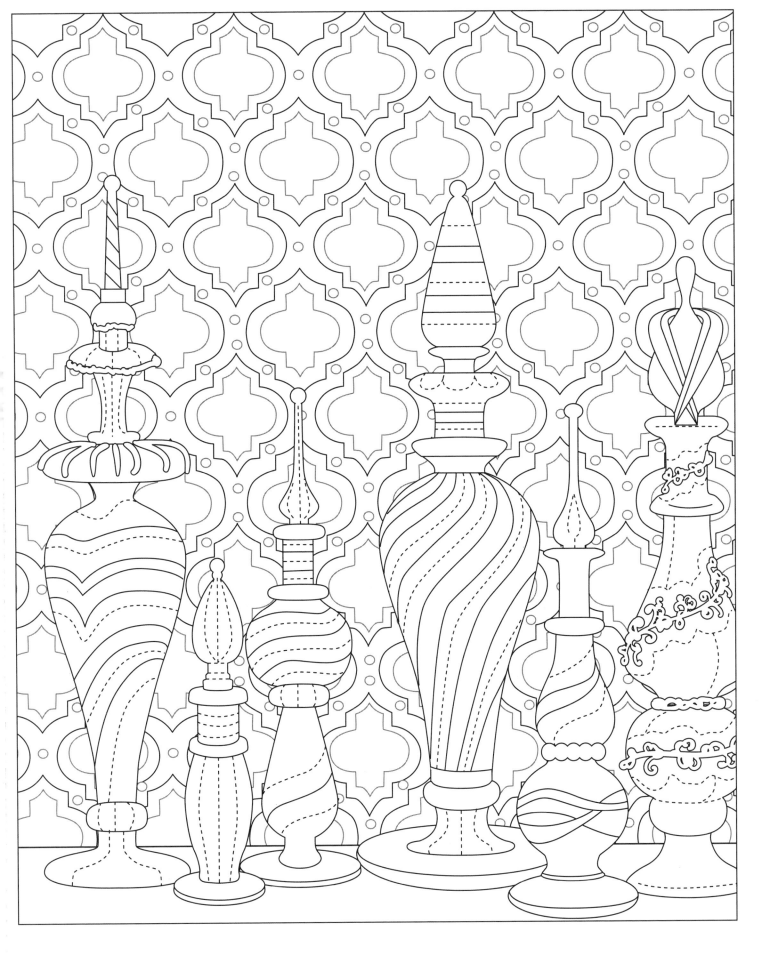

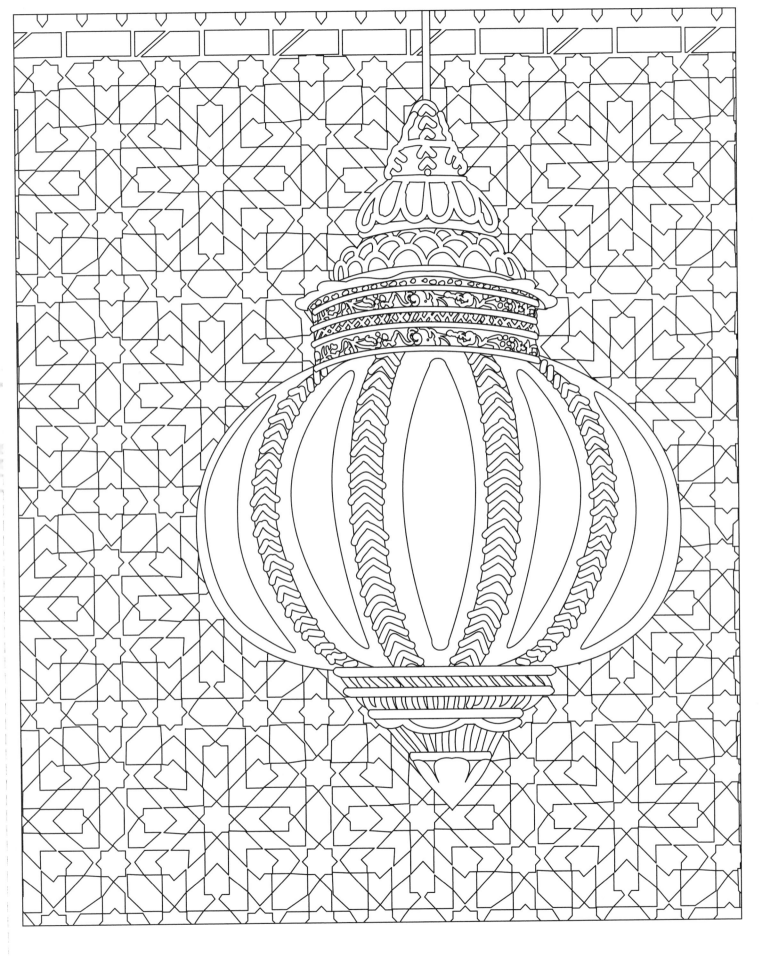

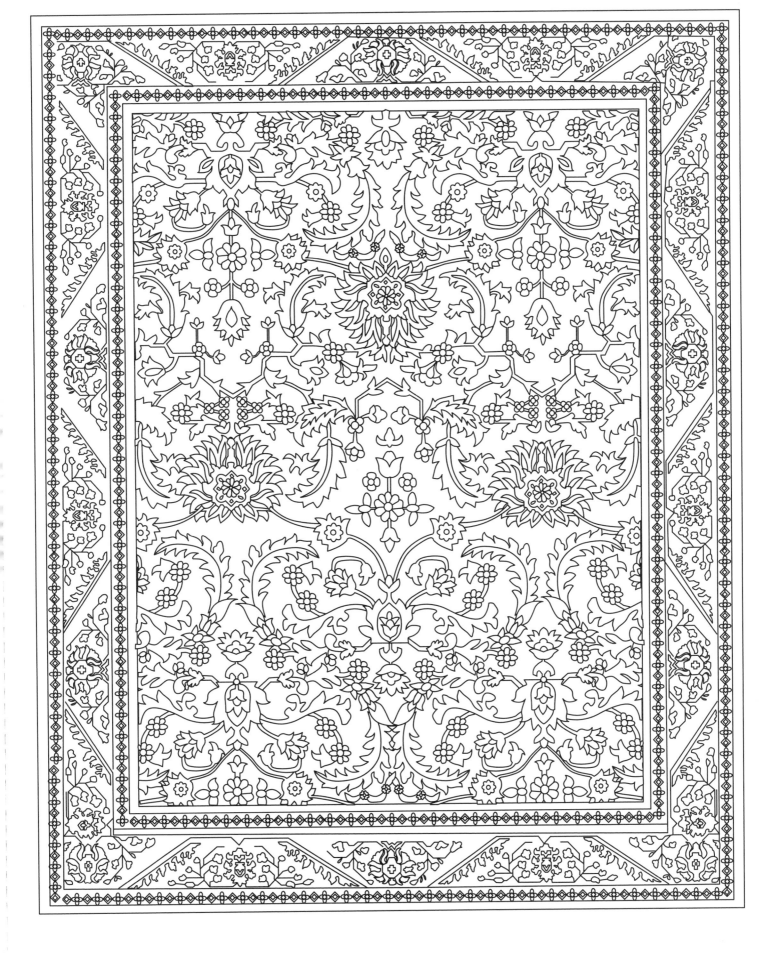

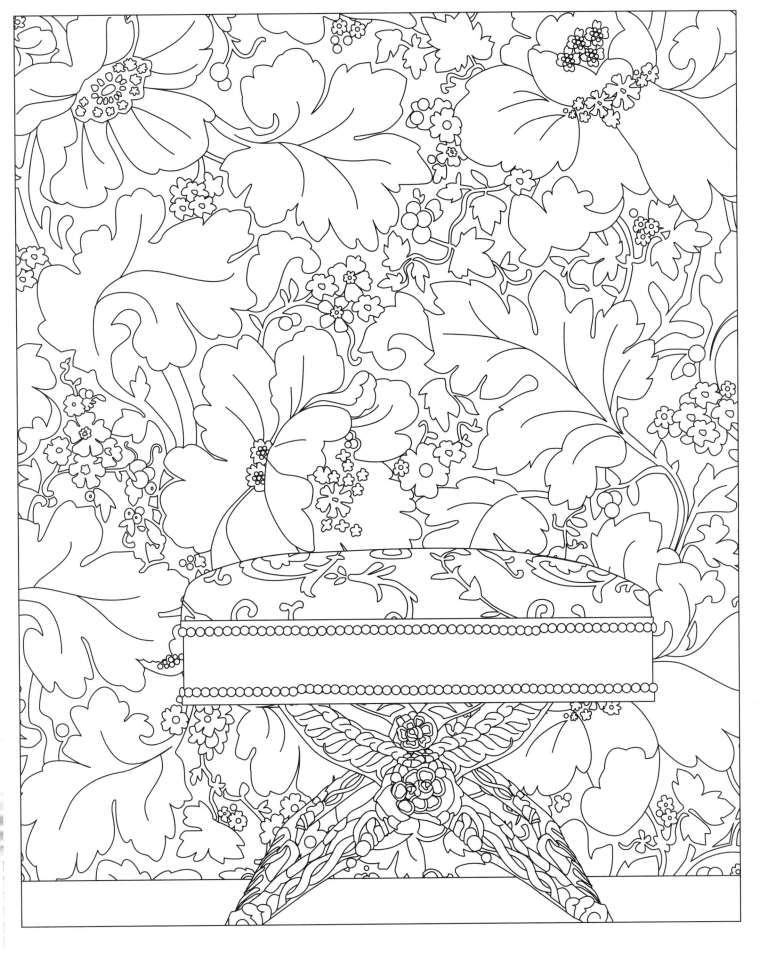

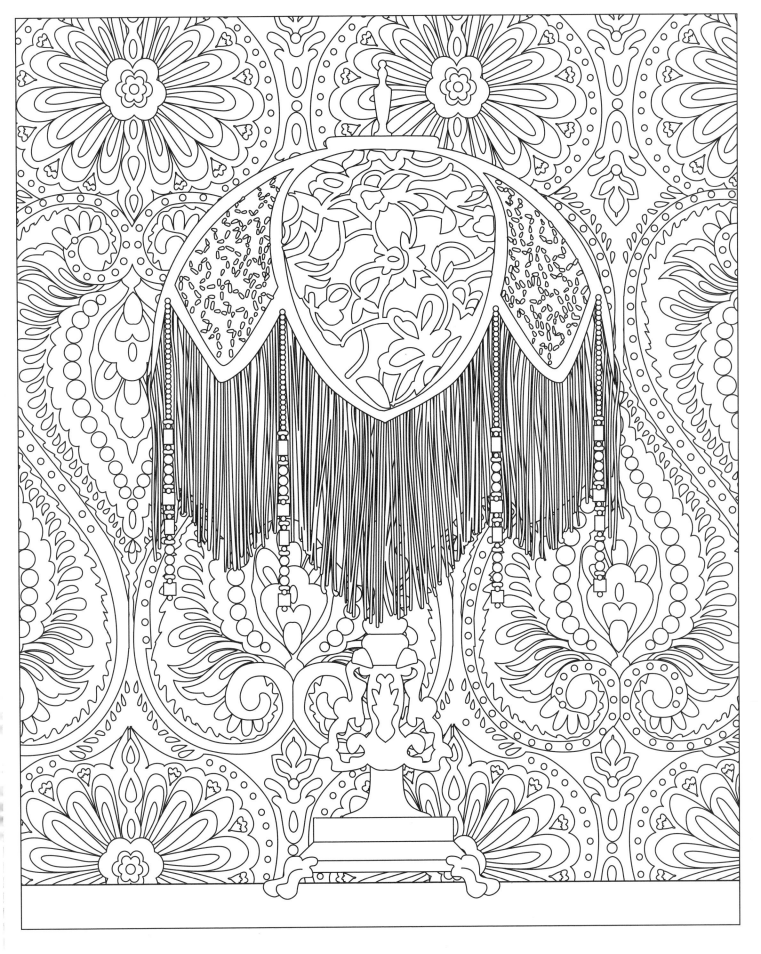

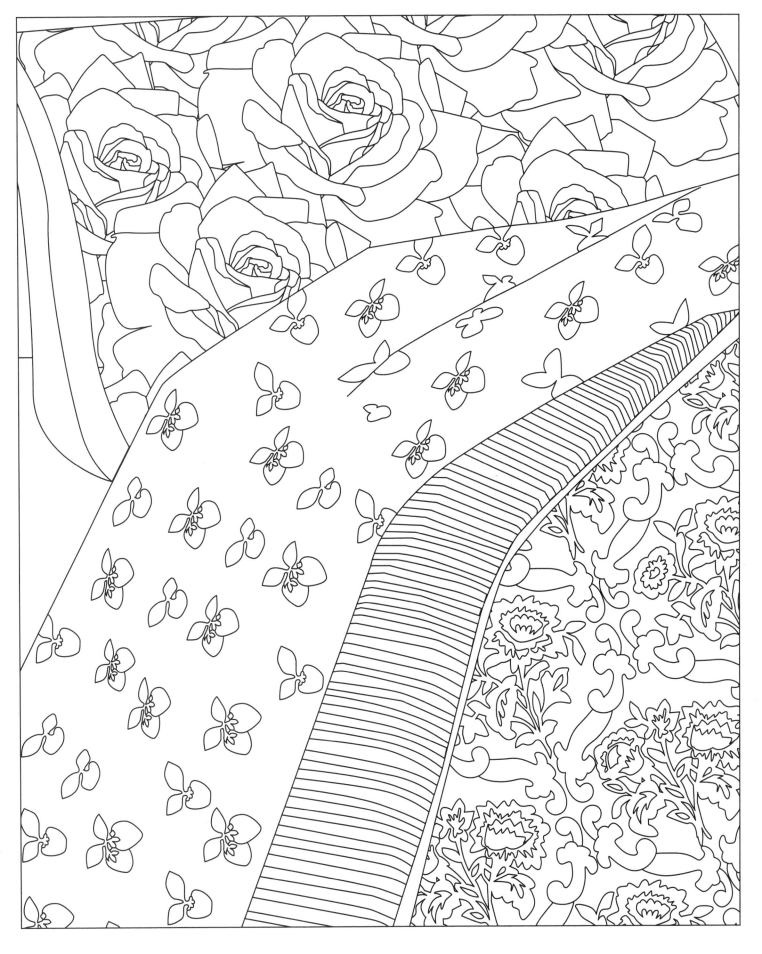

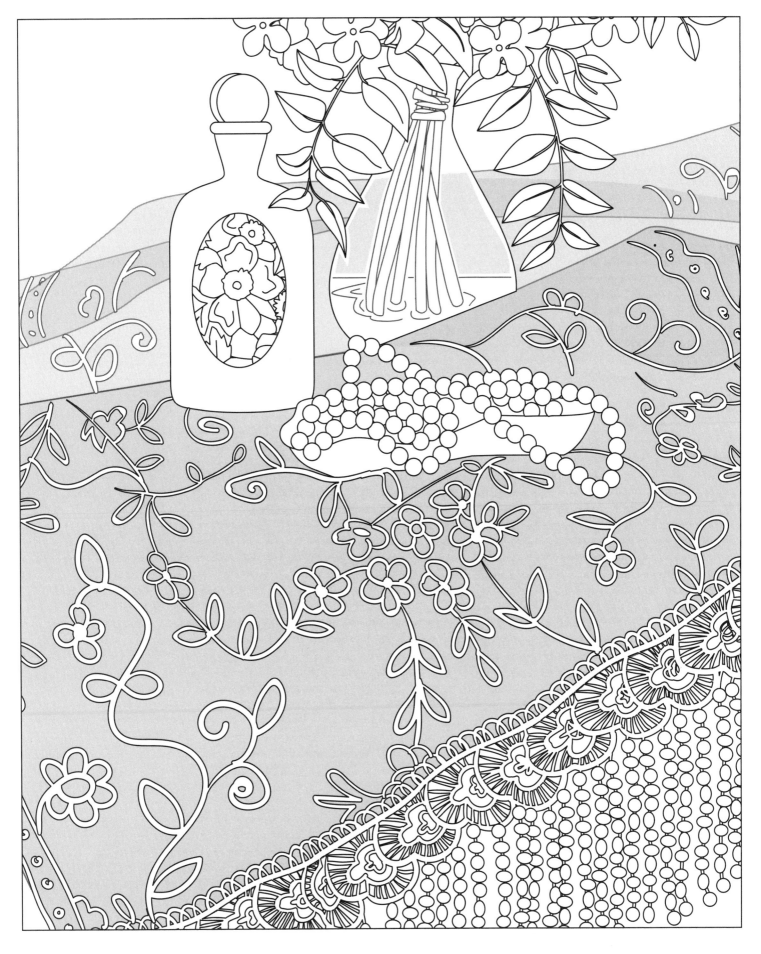

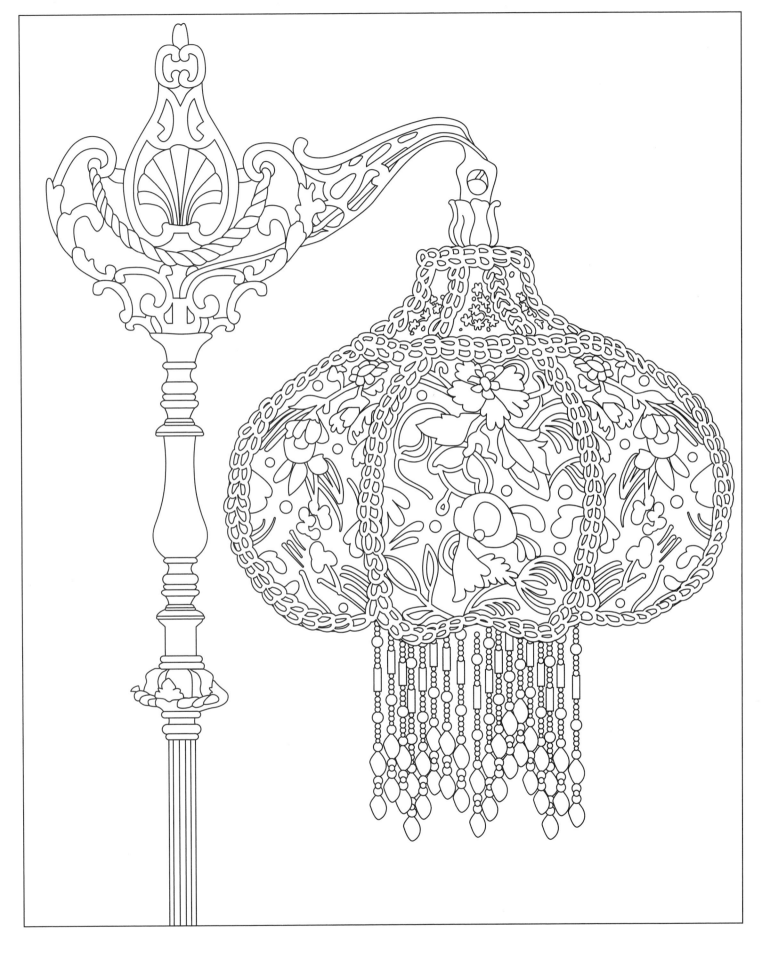

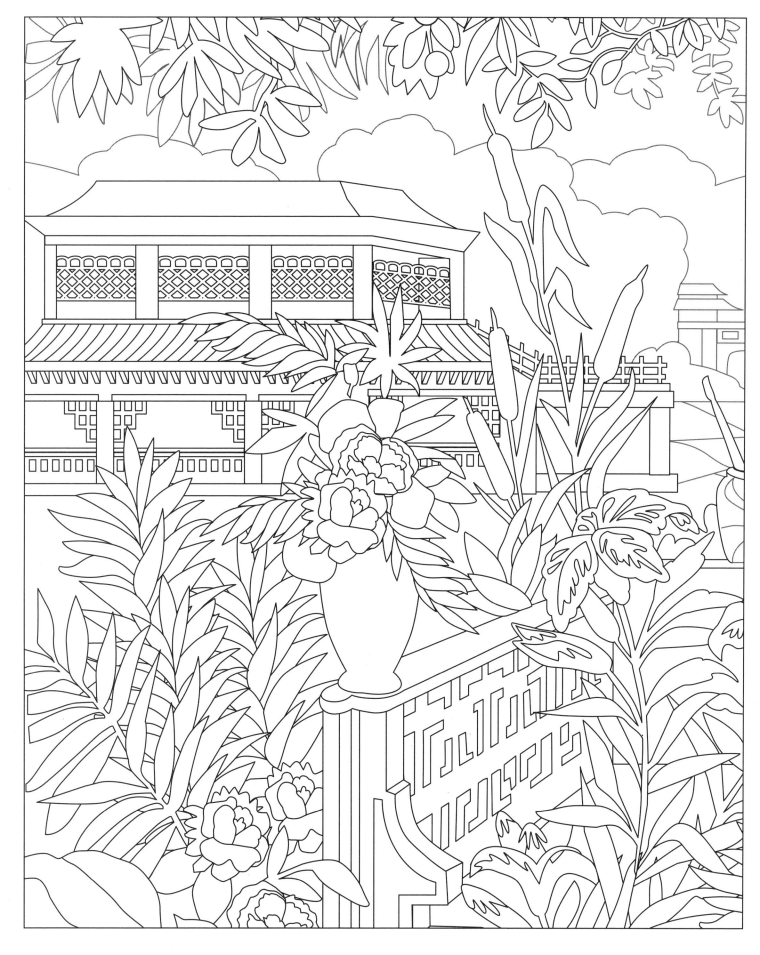

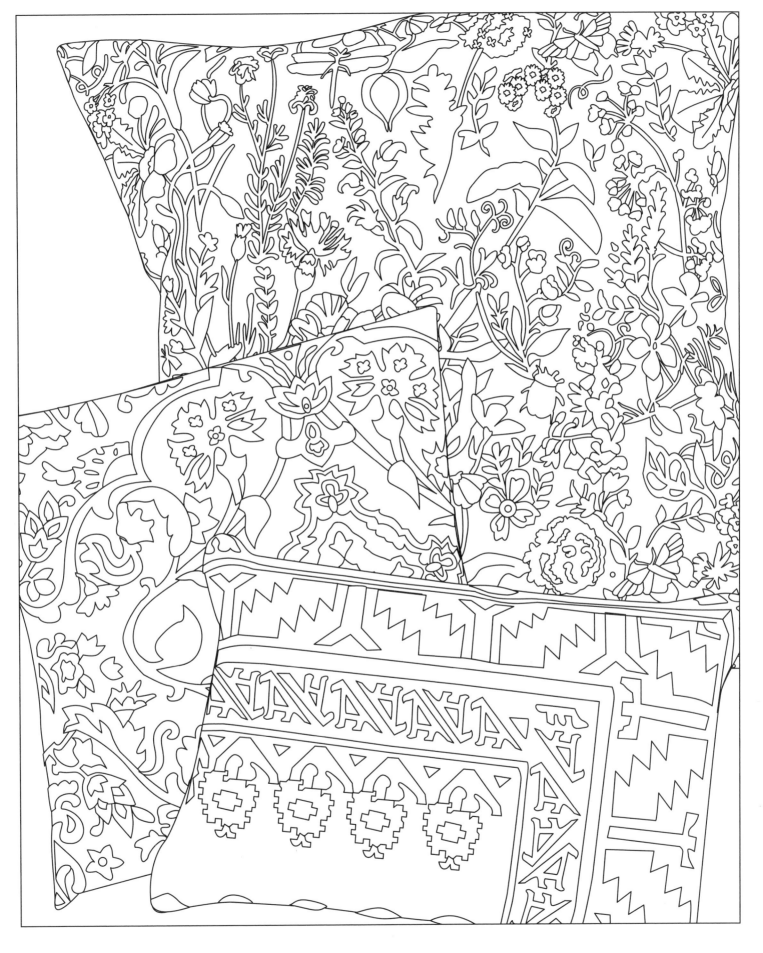

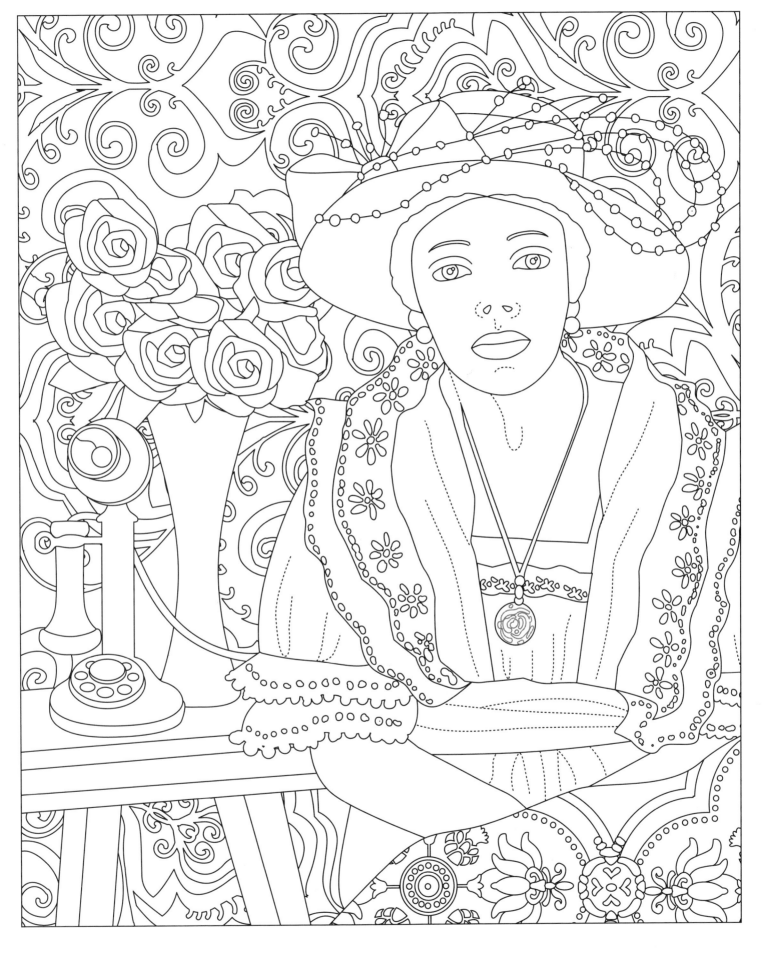

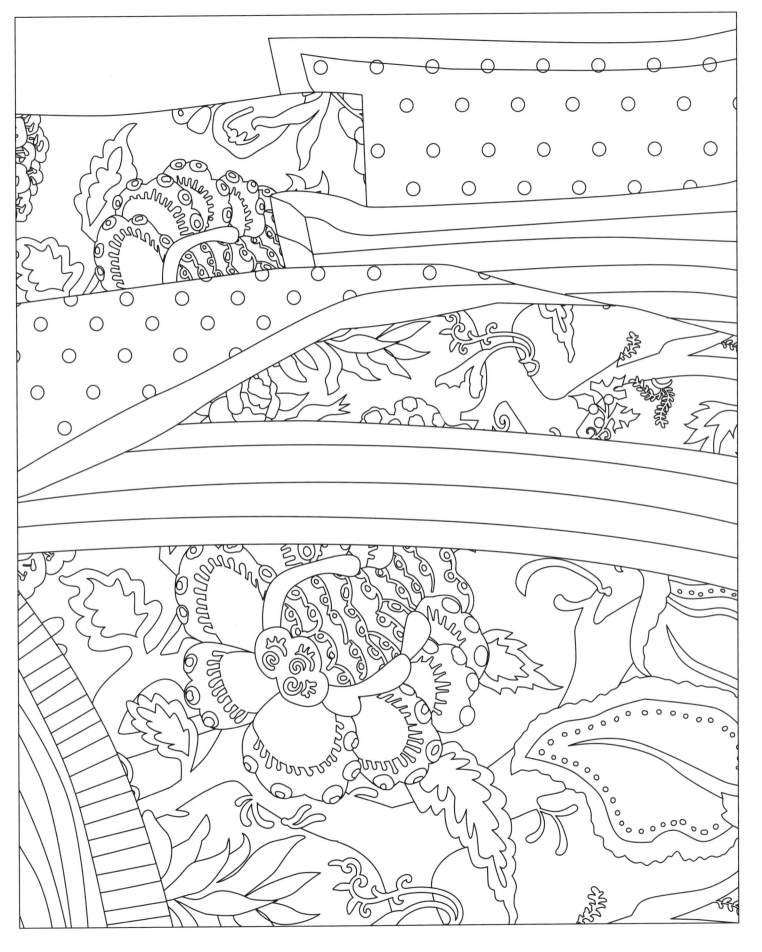

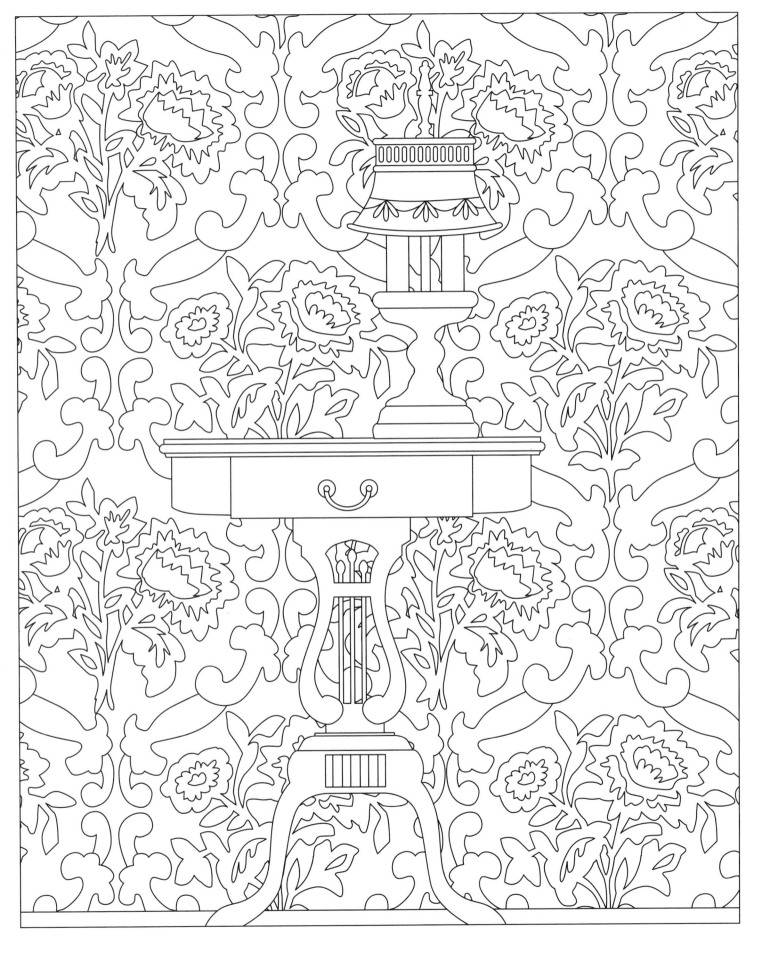

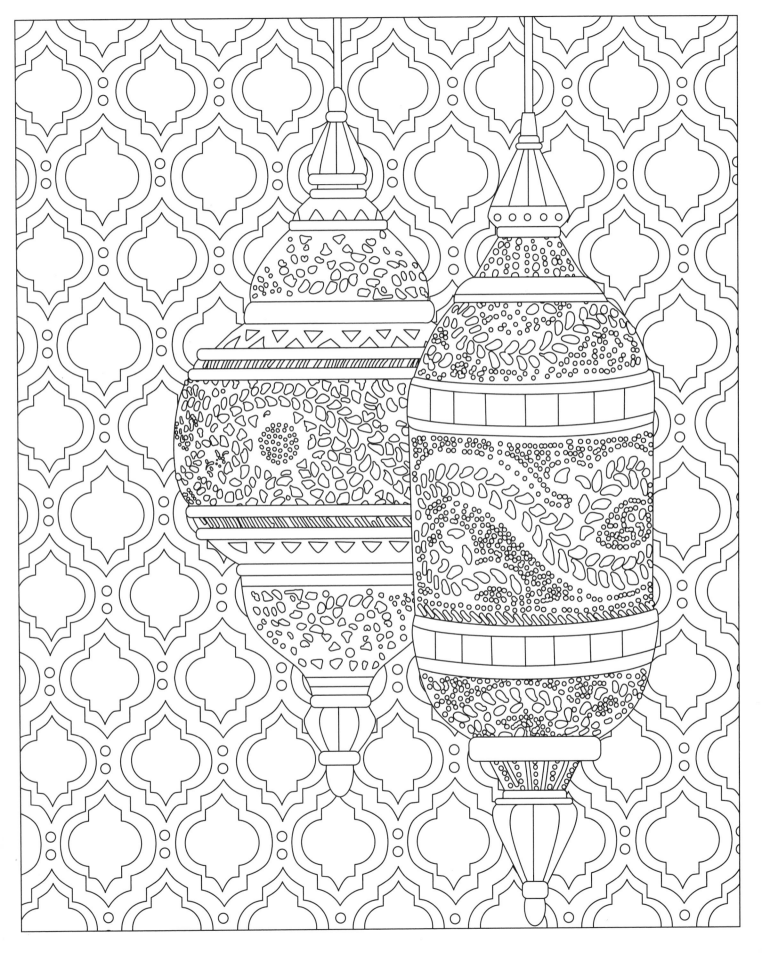

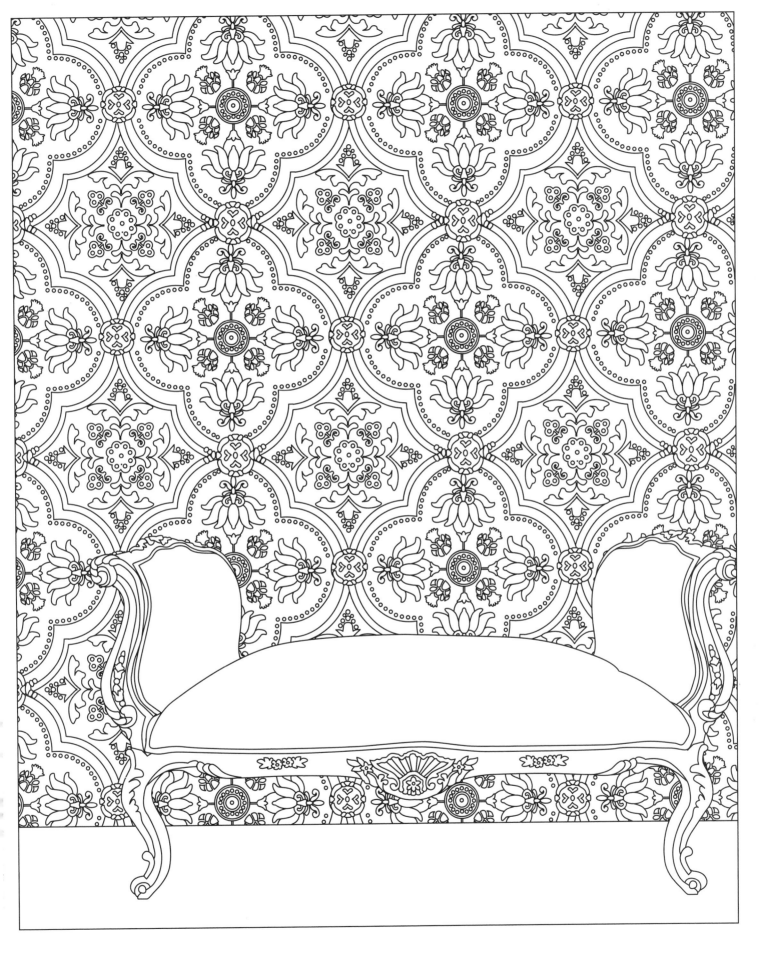

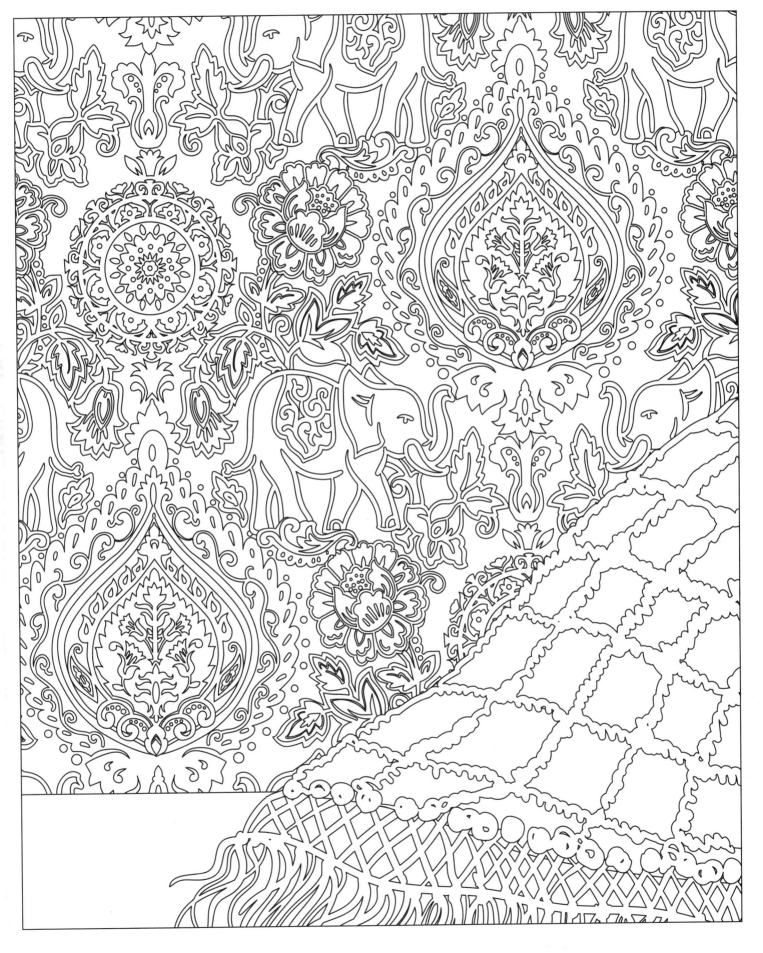

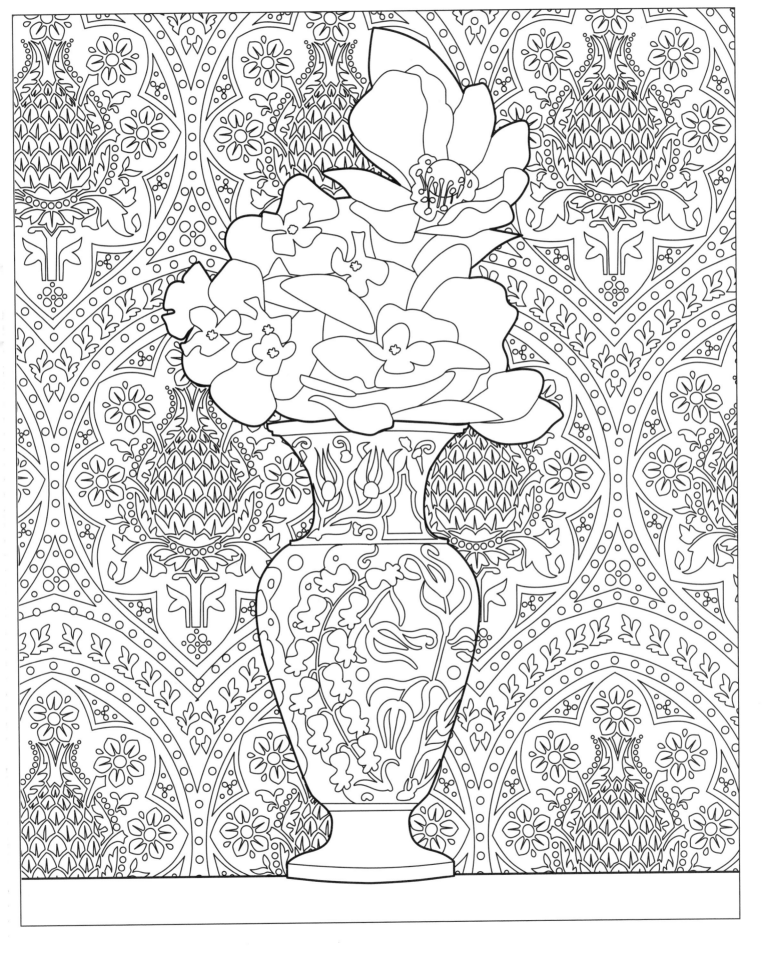

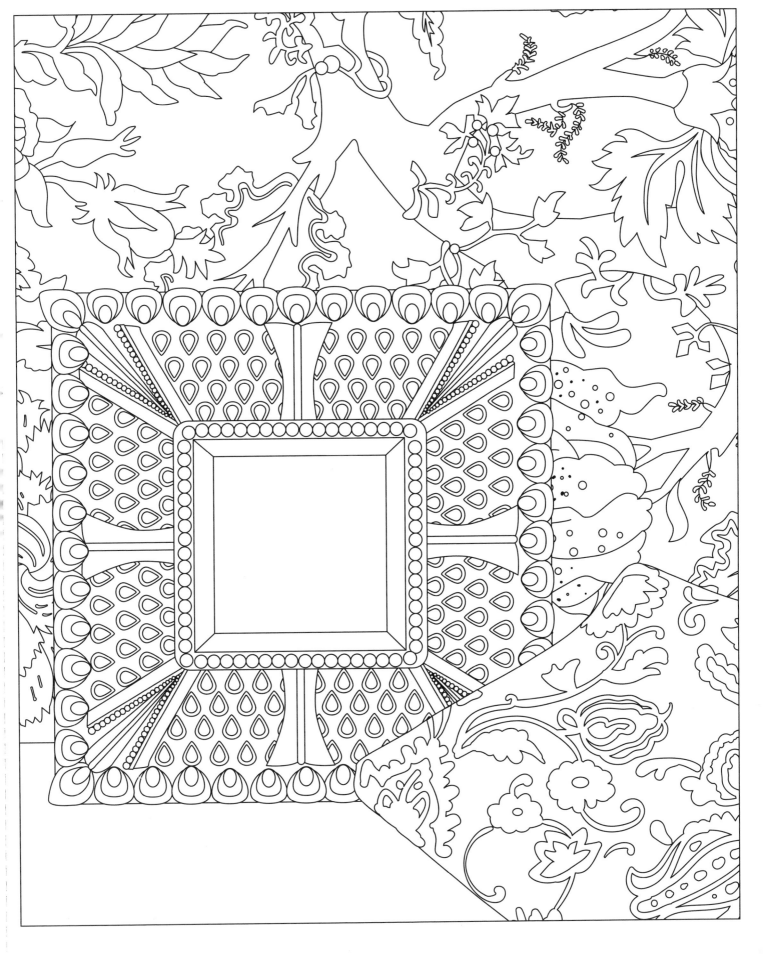

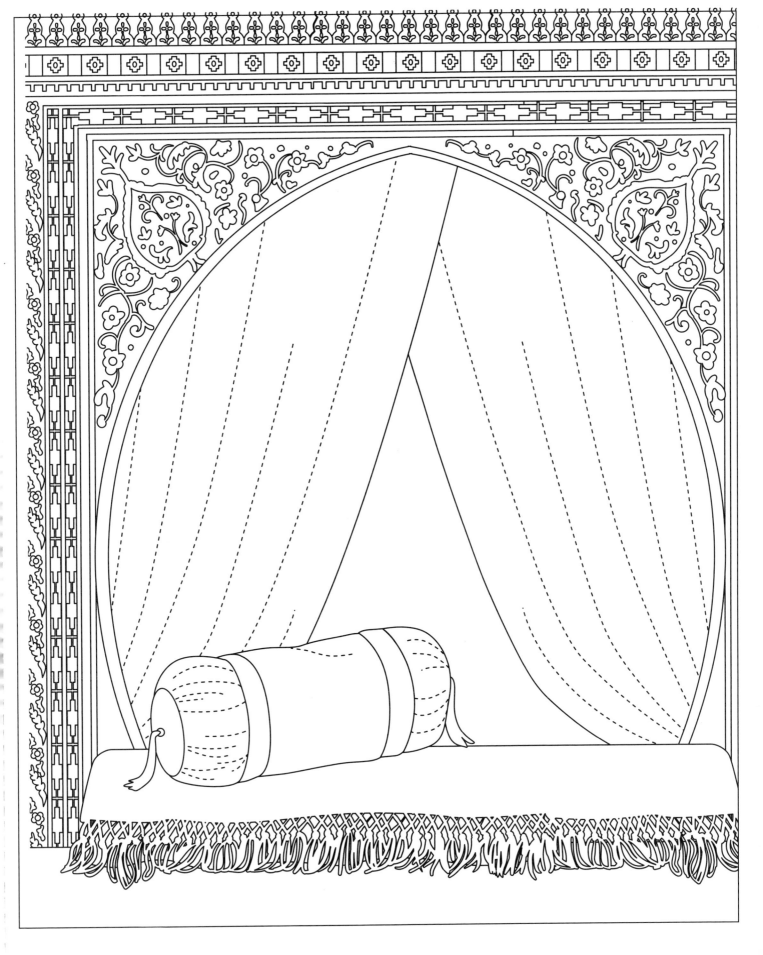

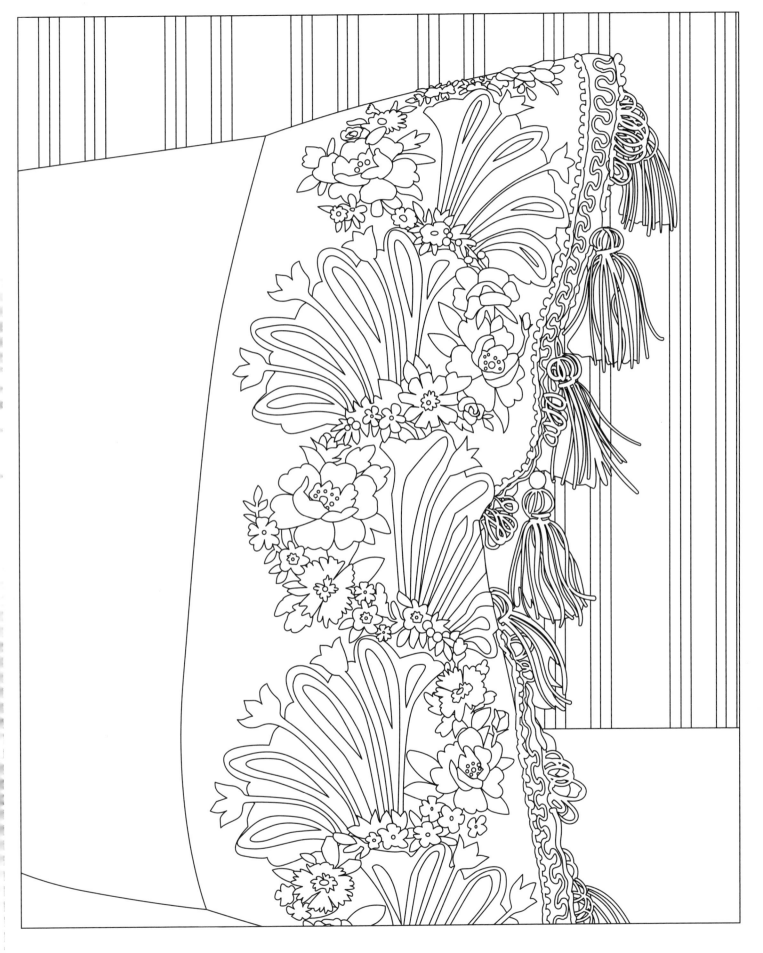

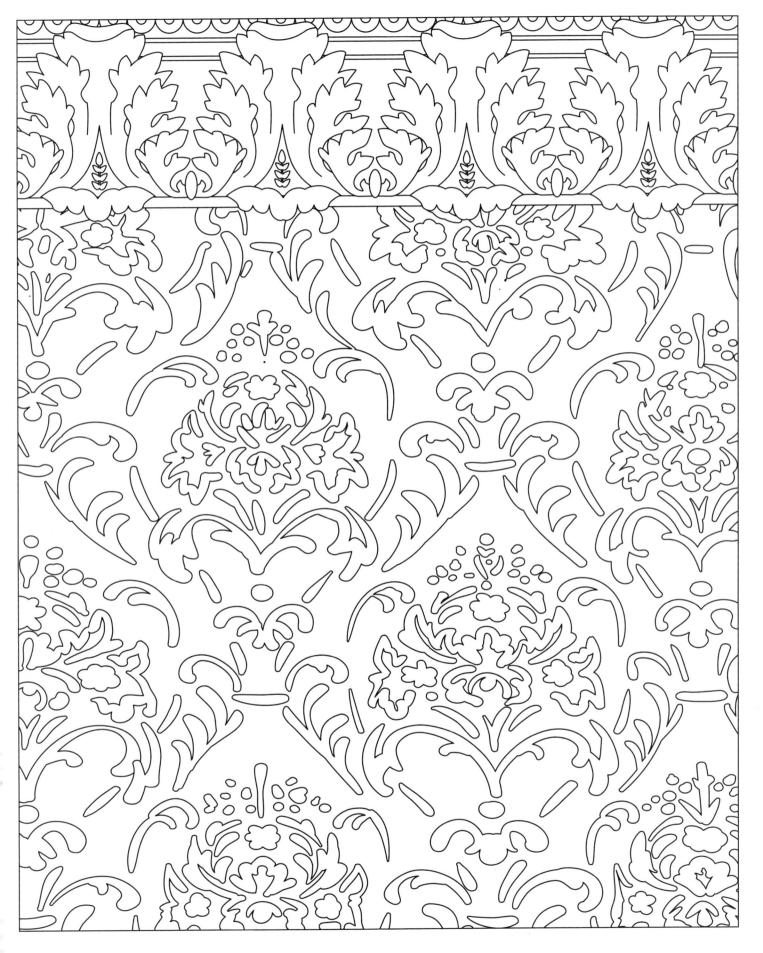

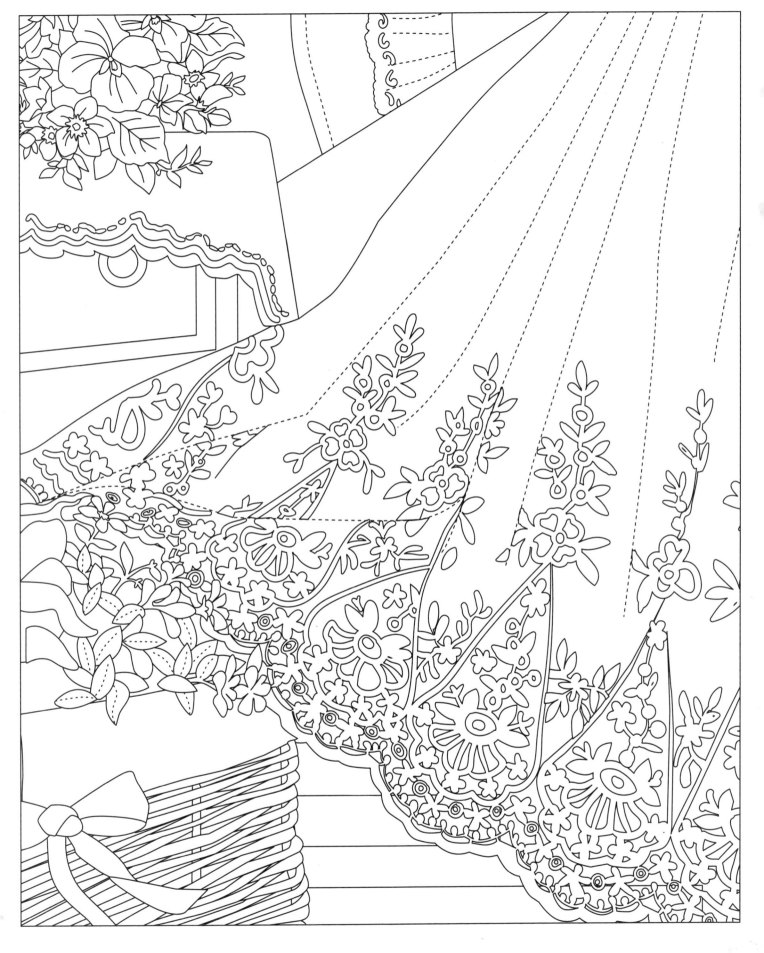

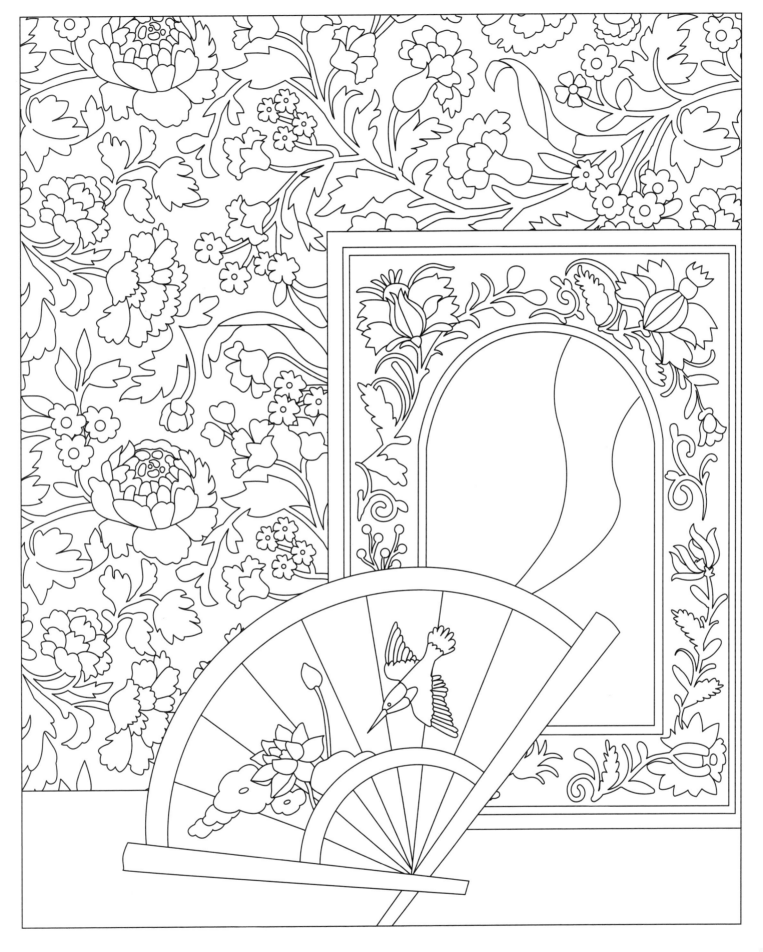

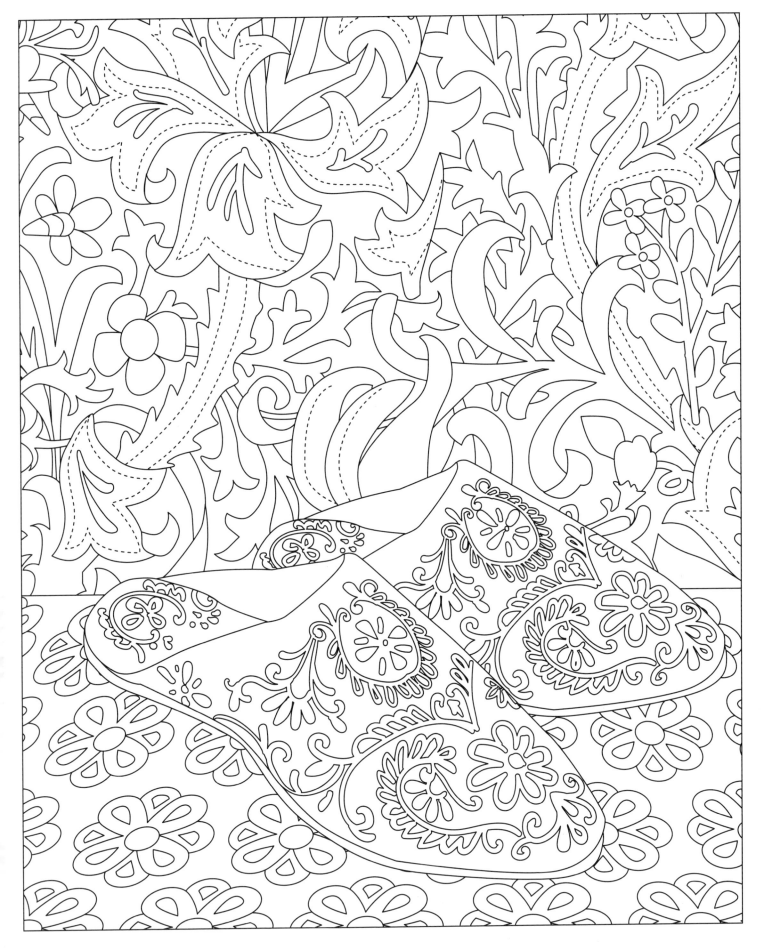

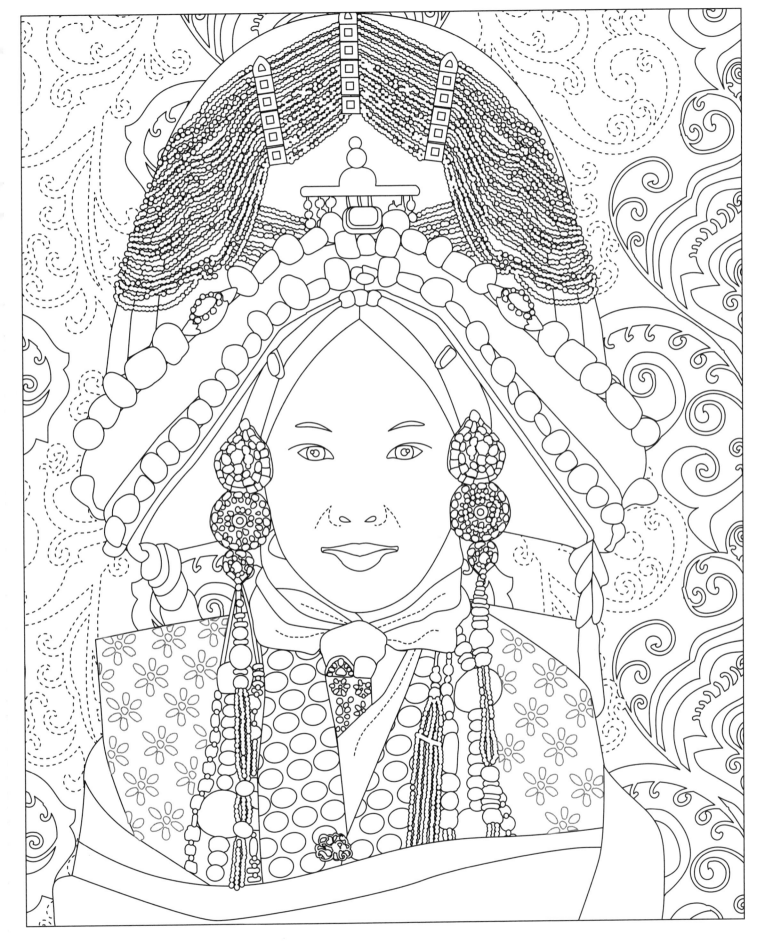

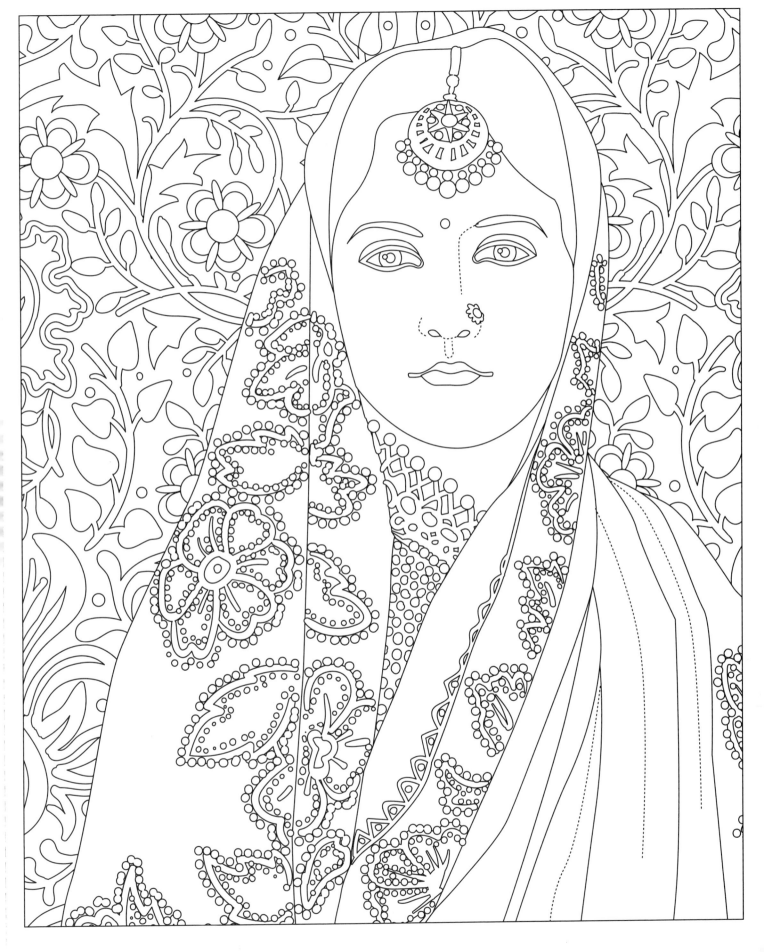

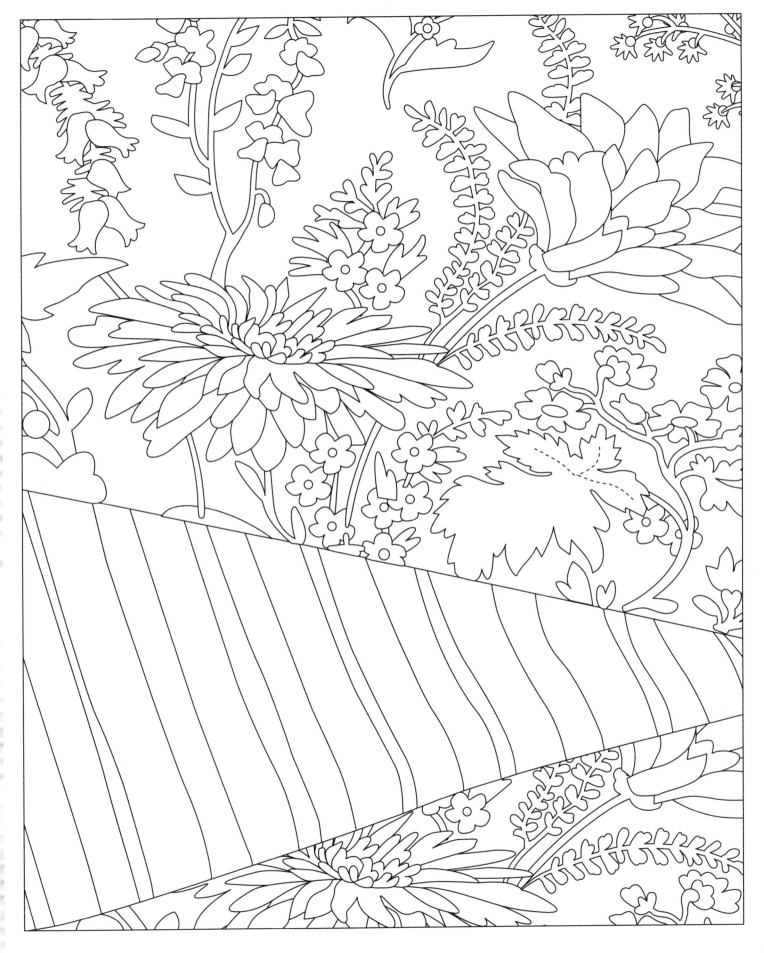

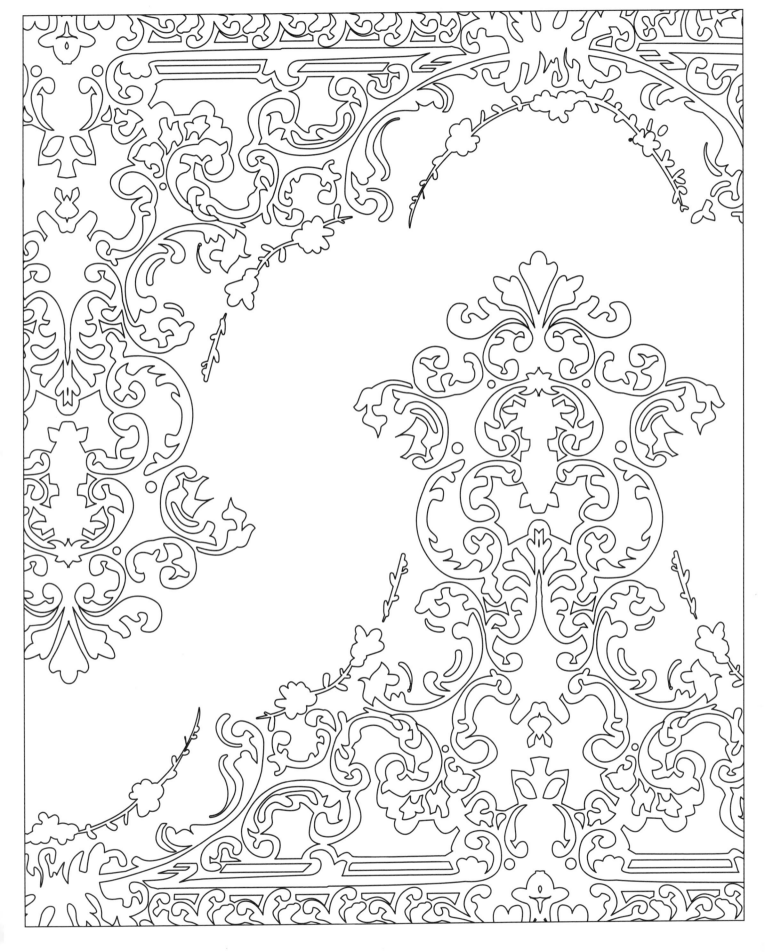

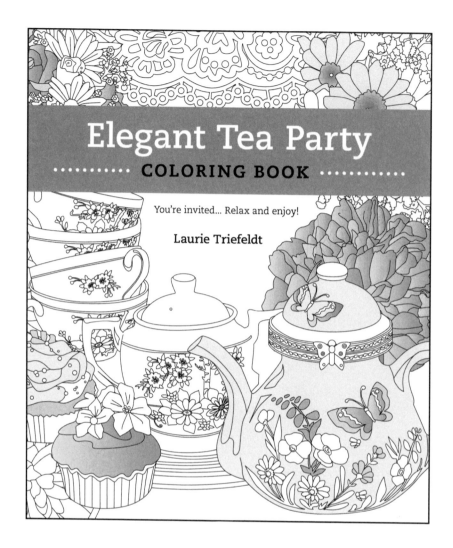

Sit down, have a cup, ease your tensions, and reinvigorate your creativity in the immersive world of the *Elegant Tea Party Coloring Book*. Hand-drawn by acclaimed artist Laurie Triefeldt, these 70 intricate and absorbing illustrations of cups, saucers, teapots, muffins, and flowers will give you hours of calming focus. Thick, high-quality paper, printed on only one side, gives you a smooth, firm coloring surface with no bleed-through, and perforated pages let you share and preserve your creative work. Like a rich cup of tea, *Elegant Tea Party Coloring Book* is a relaxing and stimulating break in your busy day.

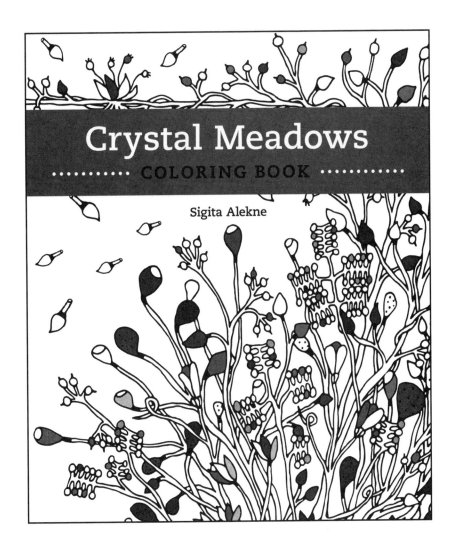

Coloring book fans will love taking a restorative excursion into the organic world of *Crystal Meadows Coloring Book*. Designed by Lithuanian artist Sigita Alekne, the images in *Crystal Meadows Coloring Book* reflect Alekne's unabashed love of nature and living things. Thick, high-quality paper, printed on only one side, gives you a smooth, firm coloring surface with no bleed-through, and perforated pages let you share and preserve your creative work. Like a cool walk into a primeval forest, *Crystal Meadows Coloring Book* will calm your restless spirit and refocus your artistic mind.

## Available at bookstores, online retailers, and at www.QuillDriverBooks.com.

**Laurie Triefeldt** was born and educated in Toronto, Canada. She is a graduate of the Ontario College of Art and the University of Windsor. Laurie and her husband Rein (an internationally respected sculptor) moved to Trenton, New Jersey in 1989.

Laurie is the creator of *World of Wonder*, the weekly, illustrated newspaper feature devoted to exploring educational themes and examining the realms of history, science, nature, and technology. Over the past 15 years, *World of Wonder* has appeared in more than 100 newspapers worldwide. In 2007, *World of Wonder* won the National Cartoonists Society's award for best newspaper illustration. It has also twice (2002 and 2006) won the Distinguished Achievement Award for Excellence in Educational Publishing from the Association of Educational Publishers. The feature is currently syndicated by Universal Uclick.

Triefeldt has written, illustrated and designed four books: *World of Wonder*, published by Kean University and the *Star-Ledger*, and *Plants and Animals*, *People and Places*, and *Elegant Tea Party Coloring Book*, published by Quill Driver Books. Triefeldt was a vital part of the *Star-Ledger* team that won the 2005 Pulitzer Prize in Breaking News Reporting.

As a graphic journalist, Triefeldt has worked for *The Courier Post*, *The Windsor Star*, and the *Newark Star-Ledger*. She has also contributed to Gannett News Service, Newhouse News Service, and United Feature Syndicate.